GHOSTS OF PLYMOUTH, MASSACHUSETTS

DARCY H. LEE

Haunted America

Published by Haunted America
A Division of The History Press
Charleston, SC
www.historypress.net

Front cover: First Parish Meetinghouse, Plymouth. *Patrice Hatcher Photography.*
Back cover: Plymouth's Gurnet Lighthouse. *Patrice Hatcher Photography*; inset: *Mayflower II.*
Courtesy Plimoth Plantation.

First published 2017

Manufactured in the United States

ISBN 9781625858788

Library of Congress Control Number: 2017940955

*This book is dedicated to my mother and late father, Marilyn and Dan Lee.
Thank you for your continued love, guidance and support.*

CONTENTS

ACKNOWLEDGEMENTS

.I was a resident of Plymouth for nearly twelve years and considered myself lucky to land in a place of history and beauty. I always wondered why no one had written a ghost-story book solely about and wholly dedicated to hauntings and horrors in Plymouth. So, here it is, just in time for the international commemoration of the 400th anniversary of the landing of the Pilgrims in 2020.

No author is alone in his or her quest to put together a book that people want to read. I would be remiss if I did not mention those who have helped me in my research of haunted happenings in Plymouth and those who have contributed to my goal of writing a historically accurate account of Plymouth's history as it relates to its folklore and tales.

My sincerest heartfelt thanks are extended to Patrice Hatcher, psychic, photographer and interior designer; Vicki Noel Harrington, owner of Spirit of Plymouth Walking Tours of America's Hometown; William Rudolph, president of the Plymouth Cordage Museum; Lucille Leary, secretary of the Plymouth Cordage Museum; Elizabeth and James; Mark Bryant, owner of Seasound Recording Studios at the Spire Center for the Performing Arts; Dot McDonough of Seasound Recording Studios; Diane Finn, retired owner and guide of Plymouth's Colonial Lantern Tours (now closed); Amy Giammasi of the John Carver Inn and Spa; Robin Ruehrwein, social media commentator and blogger at massholemommy.com; Rob Kluin, director of marketing and communications at Plimoth Plantation; and Paul Cripps, executive director of Destination Plymouth and the Plymouth County Convention and Visitors Bureau.

PREFACE

Plymouth, Massachusetts. Located on the state's South Shore and home to fifty-eight thousand people, Plymouth is known worldwide as "America's Hometown," the landing place of the Pilgrims in 1620 and the home of the first Thanksgiving. The mere mention of this seaside community evokes idyllic images of family, tradition and the proud history Americans share.

As a major tourist destination situated between Boston and Cape Cod, Plymouth welcomes more than 1.5 million visitors each year from all over the world, visitors who enjoy the area's waterfront, beaches, pine barrens, museums, historical architecture, quaint downtown, cultural activities, restaurants and so much more.

But it is not the residents of Plymouth, or those who have traveled far and wide to experience the Pilgrim story firsthand, who should cause any concern. There is a population of sorts that remains behind. When the air turns crisp and you hear the unmistakable crunch of leaves behind you on a deserted lane, you turn, and no one is there. The wind comes off the water, and you swear you hear cries of pain and desperation in its howl. You may have heard stories as a child about those who have committed dastardly deeds, some so incredible that they could not possibly be true, you say. Read on.

One word of caution before you do. I remind the reader that some of the sites and locations mentioned in this book are private residences or businesses. Others are historic sites or venues that are open to the public

during prescribed days and times. All are treasured parts of Plymouth's historic past and rich heritage. When visiting Plymouth and any sites mentioned in this book, please be mindful of laws regarding trespassing on private property and rules and restrictions regarding public land and spaces.

Now, read on.

1

CURSED PATUXET

Is Plymouth cursed? If you listen to those among us with an intuitive nature, they would suggest that the land holds on to the grief, the despair, the tragedy, the pain, the depravity, the hopelessness and the fear of its earlier generations of inhabitants, from its native people to the Pilgrims and modern-day residents. A place of great tragedy can retain the negativity of its past.

Of course, not all of Plymouth's history is marred by misfortune, catastrophe, crime and despondency. Plymouth is a big small town. Generations of families make their home in Plymouth because of the beautiful coastline, the natural environment of the pine barrens, activities and entertainment, proximity to services, good schools and a large, affordable housing stock. Dedicated stewards of the town's history help create cherished memories for visiting tourists from around the world. Simply put, residents enjoy a good quality of life in Plymouth, and visitors enjoy themselves immensely.

Still, there remains an undercurrent of something that is hard to put one's finger on. There is a darkness, a heaviness at times and in places, an impression that the heartbreaks and misfortunes of the past are woven into the fabric that is Plymouth. This begs the question: is Plymouth cursed?

In the early seventeenth century, a plague decimated all of the Patuxet Native American tribe living in what is now Plymouth, leaving Squanto as the sole survivor. Squanto survived because he was not on the continent of North America at the time of the plague. He had been kidnapped into

slavery and sent to Europe. In 1619, he was released and returned to Patuxet (Native American for "land of the little falls"). What remained of his village were the bleached bones of his fellow tribespeople and relatives. Did this plague, a curse perhaps, lay the groundwork for the tortuous first year experienced by the Pilgrims?

In 1620, a community of Separatists from the Church of England departed Plymouth, Devon Harbor, on the *Mayflower*, after already having had an arduous trip from Leyden, Holland, to Dartmouth, England, and then to Plymouth. Two ships commissioned for the transatlantic voyage, the *Mayflower* and the *Speedwell*, were to take the "Saints and Strangers" to a new England in the Virginia Colony. The "Saints" (the name the Pilgrims gave themselves) and the "Strangers" (the name they gave to the other passengers who were not members of their religious community), 102 in all, fully expected to reach the New World in the early fall of 1620. But the *Speedwell* took on water and forced the two ships back to Dartmouth shortly after their departure in August. It took nearly a month for the group to finally embark on only one ship, the now very crowded *Mayflower*, from Plymouth. They would be traveling across the Atlantic during the stormiest and most dangerous of months.

The *Mayflower* nearly met its peril when the fierce storms of the North Atlantic caused a crack in the main beam of the vessel. A giant screw repaired the crack, but now the ship was off course and headed toward Cape Cod. The call "Land ho!" was not met with jubilation by the Pilgrims. Relief, yes, but not jubilation. What greeted them could have very well been confused with the Sahara Desert. Sand, wind, little vegetation and no fresh water awaited them. Try as they might to reach the passengers' destination of the mid-Atlantic, Captain Christopher Jones and his crew attempted to traverse the dangerous shoals of the outer Cape but were forced to turn back. *Mayflower* docked in present-day Provincetown Harbor. Despite being at sea for sixty-six days, the Saints were indeed grateful for being saved. They were led in prayer by Elder William Brewster reciting Psalm 100:

Shout to Jehovah, all the Earth.
Serve ye Jehovah with gladness.
Before Him come with singing mirth.
Know that Jehovah, he God is.
It's He that made us, and not we.
His folk, and sheep of his feeding.
O, with confession, enter yee

His gates, His courtyards with praising.
Confess to Him, Bless ye His name.
Because Jehovah, He good is.
His mercy ever is the same.
And His faith, unto all ages.[1]

On the voyage over, one passenger had already been lost at sea. While a search party led by William Bradford left the *Mayflower* in its shallop (a small sailboat) to find a suitable location for habitation with fresh water, another terrible tragedy occurred. Dorothy May Bradford, wife of William Bradford, drowned in Provincetown Harbor. How Mrs. Bradford met her tragic fate is up for debate. Did she slip and fall off *Mayflower*'s deck? Was she pushed? Most probably not. Did she cause her own death by suicide? Many believe this was so.

The Bradfords had left a boy of about three years old behind in England, a son they might never see again. The trip across the ocean was treacherous and life-threatening. Dorothy had arrived in a very strange land among only a handful of people she knew (only about half the people on the *Mayflower* were Separatists.). When the final destination turned out to be a barren and dangerous-looking place, her husband left her among the other passengers and crew—some of whom were less than respectful to the Saints—in search of a location where the group could survive until they could find their way to Virginia, or somewhere else. One can only imagine that Dorothy May Bradford believed her future to be tenuous at best in this new and unforgiving land.

When William Bradford returned from his exploration, he learned of his beloved's fate. A prolific writer and author of *Of Plymouth Plantation*, Bradford remained mute about his wife's death until later in life. In a poem, he wrote:

Faint not, poor soul, in God still trust,
Fear not the things thou suffer must;
For, whom he loves he doth chastise,
And then all tears wipes from their eyes.[2]

While exploring the Cape, Bradford and his party discovered evidence of the Native American tribe of the region, the Wampanoags, including weetus (shelters), pots, corn and a burial ground. The Pilgrim band, among them *Mayflower* captain Christopher Jones and military captain Myles Standish, along with a group of ailing men (illness and hunger were already making

their way through the small community), did indeed desecrate the graves of a European sailor and Native American child, stole corn from the reserves of the native people and took items from their weetus.[3] Nathaniel Philbrick describes their activities in his best-selling book *Mayflower*:

> *Among the Indians' clay pots, wooden bowls, and reed baskets was an iron bucket from Europe that was missing a handle. There were several deer heads, one of which was still quite fresh, as well as a piece of broiled herring. As they had done with the graves of the blond-haired sailor and Indian child, the Pilgrims decided to take "some of the best things" with them. Looting houses, graves, and storage pits was hardly the way to win the trust of the local inhabitants. To help offset the damage they'd already done, they resolved to leave behind some beads and other tokens for the Indians "in a sign of peace." But it was getting dark. The shallop had returned, and they planned to spend the night back aboard the Mayflower. They must be going. In their haste to depart, they neglected to leave the beads and other trade goods. It would have been a meager gesture to be sure, but it would have marked their only unmistakable act of friendship since their arrival in the New World.[4]*

Shortly thereafter, the shallop embarked again on a quest deeper into Cape Cod Bay. It was during this venture, writes Philbrick, that the Pilgrims came upon an island off the coast of present-day Plymouth Harbor. Named for *Mayflower* pilot John Clark, who was the first to set foot on it, Clark's Island would later be the site of the Pilgrims' first Sabbath when the *Mayflower* dropped anchor in Plymouth Harbor.

It is when the latest expedition party returned to *Mayflower* in Provincetown Harbor that they learned the terrible tragedy that had occurred. Dorothy May Bradford was dead.

Had a curse befallen the Pilgrims?

The Pilgrims were given a charter to settle in Virginia, not Cape Cod or Massachusetts. Wrong place, wrong time. It was necessary for the settlers to legally establish themselves as a colony of Great Britain. Hence, the Mayflower Compact was drawn up and agreed to, creating a law-abiding colony with an elected body of men from among the passengers and naming it Plymouth. Later, the Pierce Patent would make it legal for the colonists to be in Plymouth, but it was the Mayflower Compact that helped to secure their place in the New World.

The *Mayflower* made its way to Plymouth Harbor, where the passengers and crew lived aboard the ship for most of the first winter. The Pilgrims'

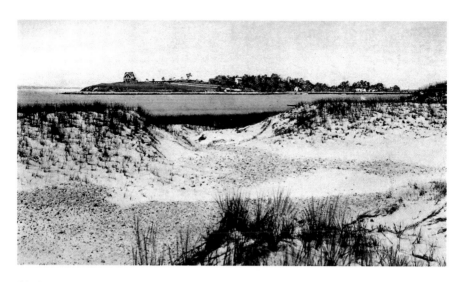

Clark's Island, named for *Mayflower* pilot John Clark. This is the site of the Pilgrims' first Sabbath in 1620. *C. T. American Art.*

fort and village was being established by those healthy enough to work. In the meantime, the dreadful conditions within the ship and the icy cold exacerbated an already malnourished, broken and sickly population. Of the 102 Saints and Strangers who sought a new life in a new land, only 50 would survive the first winter in Plymouth.

The Pilgrims had decided to make their home in Plymouth at the site of the former settlement of the Patuxet Indians. Philbrick describes the scene the Pilgrims came upon:

> *The biggest advantage of the area was that it had already been cleared by the Indians. And yet nowhere could they find evidence of any recent Native settlements. The Pilgrims saw the eerie vacancy of this place as a miraculous gift from God. But if a miracle had indeed occurred at Plymouth, it had taken the form of a holocaust almost beyond human imagining. Just three years before, even as the Pilgrims had begun preparations to settle in America, there had been between one thousand and two thousand people living along these shores.*
>
> *Then, from 1616 to 1619, disease brought this centuries-old community to an end. No witness recorded what happened along the shores of Plymouth.... No Native dwellings remained in Plymouth in the winter of 1620, but gruesome evidence of the epidemic was scattered all around the area. "[T]heir skulls and bones were found in many places lying still above the ground..."*

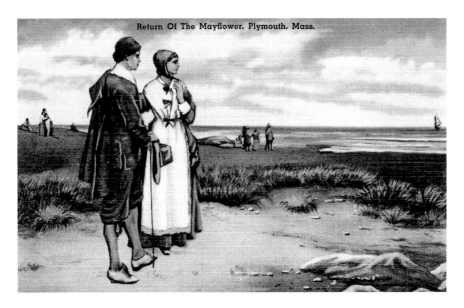

Above: Vintage postcard of George H. Boughton's lithograph *Return of the Mayflower*, depicting the ship's departure from Plymouth Harbor on its return voyage to London on April 5, 1621. *Smith's Inc., Plymouth, Massachusetts.*

Opposite: Cole's Blacksmith Shop, constructed circa 1684, as it appeared in 1908. It was operated and owned by Ephraim Cole, son of James Cole, for whom Cole's Hill is named. The building has since been razed. *Robbins Bros., Boston and Germany.*

> *Bradford wrote, "a very sad spectacle to behold." It was here, on the bone-whitened hills of Plymouth, that the Pilgrims hoped to begin a new life.*[5]

Was the Patuxet land cursed?

Burying the Pilgrim dead was an arduous task. For hundreds of years, legend had it that the Pilgrims buried their dead at night so as not to alert the Native Americans of their tremendous losses and vulnerabilities; however, some people say that when night fell, the bodies of the dead were brought to key locations on Plymouth's hilly terrain and propped up in order to give the appearance of a large contingent of guards on watch. Do they keep watch today?

We do know that most of the Pilgrims who passed during that first winter were buried on Cole's Hill. Named for James Cole, who placed a dwelling on the hill in the 1630s, the hill is at the foot of Leyden Street, bordering Carver Street at its greatest height and Water Street at its base.[6] Today, townspeople and tourists sit and picnic on it during

Plymouth's Thanksgiving and Fourth of July parades. The Old Colony Club commemorates Forefather's Day annually at daybreak on December 22 by firing a cannon over the hill.

After that first winter of 1620–21, Cole's Hill most likely was not used as a cemetery. Other uses followed over the centuries; it has been passed down that the hill was the site of a tavern and a blacksmith's shop.

It served as a watch post during the American Revolution, and now it is a spacious, yet steep, green park owned by the Pilgrim Society and Pilgrim Hall Museum. In the 1960s, Cole's Hill was placed in the National Register of Historic Places and was recorded as a National Historic Landmark. The tercentenary edition of John A. Goodwin's book *The Pilgrim Republic* describes the moment when it first became apparent that Cole's Hill was indeed a burial ground for the Pilgrims:

> *In a storm of 1735 a torrent pouring down Middle Street made a ravine in Cole's Hill and washed many human remains down into the harbor. In 1809 a skull with especially fine teeth was exposed. In 1855 these graves were exposed in laying the public conduit on Cole's Hill. In one grave lay two skeletons, pronounced by surgeons male and female. The man had a particularly noble forehead; and it was fondly surmised that here were the remains of Mr. and Mrs. Carver. These found a new grave on Burial Hill; but the other relics, with barbaric taste, were placed in the top of the stone canopy over Forefathers' [Plymouth] Rock. In 1879, during some work on the southeast side of the hill, many more bones were unearthed, and some, with questionable taste, were carried away by the spectators in remembrance of their "renowned sires."* [7]

Eleven skeletons were recovered in just over a 148-year period. When a new canopy for the Plymouth Rock was constructed in the 1920s, the bones were moved to a sarcophagus atop Cole's Hill, where they remain today.

The Pilgrims found themselves in a fight for survival, not just from the elements and illness but also in a manner of diplomacy. The stories of English-speaking Squanto, "friend to the Pilgrims," and Samoset, who introduced the Pilgrims to Wampanoag Pokanoket Sachem Massasoit, are well known. Most certainly, without their aid and knowledge of the land, the Pilgrims would have been victims of possible starvation. With regard to diplomacy, the Pilgrims found themselves thrust into an environment where the Native American tribes had previously established boundaries and feuds

Sarcophagus atop Cole's Hill that holds the remains of the Pilgrims who had been buried at Cole's Hill during the first winter of 1620–21. *Patrice Hatcher Photography.*

among themselves. Without an alliance between the Pilgrims and Sachem Massasoit, they would have fallen prey to the Massachusett tribe, who were planning a dangerous attack on the village at Plymouth.

Philbrick writes of the treaty:

> *Bradford and* [Edward] *Winslow recorded the agreement with the Pokanoket sachem* [Massasoit] *as follows:*
>
> 1. *That neither he nor any of his should injure or do hurt to any of our people.*
> 2. *And if any of his did hurt to any of ours, he should send the offender, that we might punish him.*
> 3. *That if any of our tools were taken away when our people were at work, he should cause them to be restored, and if ours did any harm to any of his, we should do the like to him.*
> 4. *If any did unjustly war against him, we would aid him; if any did war against us, he should aid us.*
> 5. *He should send to his neighbor confederates, to certify them of this, that they might not wrong us, but might be likewise comprised in the conditions of peace.*

Statue of Massasoit, Plymouth, Mass.

Statue of Sachem Massasoit atop Cole's Hill overlooking Plymouth Harbor. *Smith's News Store, Plymouth, Massachusetts.*

6. That when their men came to us, they should leave their bows and arrows behind them, as we should do our pieces when we came to them.[8]

This peace treaty between the Pilgrims and the Pokanokets would last for fifty years, until the time of King Philip's War (1675–76). Ironically, King Philip's War was named for Massasoit's son Metacomet, who adopted an English name to further the friendly relations his father had established with the English settlers. King Philip was also known as Metacom, or Pometacom. It was common for natives to take other names, and King Philip had on several occasions signed as such and had been referred to by other natives by that name. King Philip's War was an armed conflict between Native American tribes and New England settlers. It would be one of the most deadly and damaging conflicts of the seventeenth century and was the aggressive lasting end to any peace in the region between colonists and Native Americans.[9]

Prior to King Philip's War, when the bond was still strong between the English settlers and the Pokanokets, Sachem Massasoit and one of his advisors, Hobbamock, a Pniese, the strongest of legendary warriors who it was believed could not be killed, alerted Captain Myles Standish of impending danger for both the Plymouth settlement and another English one at Wessagusset (now Weymouth). The Massachusett tribe was going to attack the settlements with the help of other neighboring tribes and wipe out the English.

Not to be outsmarted by the Massachusett tribe, Standish led a group of warrior Pilgrims, along with Hobbamock, on a surreptitious trade mission to Wessagusset. The plot, concocted by Sachem Obtakiest of the Massachusett and to be led by warriors Wituwamat and Pecksuot, was foiled. A massacre of gruesome proportions ensued, as described in Philbrick's *Mayflower* and in Pilgrim Edward Winslow's own words:

Once they had all sat down and begun to eat, the captain [Standish] signaled for the door to be shut. He turned to Pecksuot and grabbed the knife from the string around the pniese's neck. Before the Indian had a chance to respond, Standish had begun stabbing him with his own weapon. The point was needle sharp, and Pecksuot's chest was soon riddled with blood-spurting wounds. As Standish and Pecksuot struggled, the other Pilgrims assaulted Wituwamat and his companion. "[I]t is incredible," Winslow wrote, "how many wounds these two pnieses received before they died, not making any fearful noise, but catching at their weapons and striving to the last."[10]

A total of seven Massachusetts were killed. Standish brought home the head of Wituwamat wrapped in linen. It was planted on a pole at the Fort House. The decaying skull and its bloodstained linen "flag," the linen in which Standish brought the head back from Wessagusset, remained and flew over Governor William Bradford's wedding ceremony to Alice Southworth. Both were symbolic reminders to the other tribes who tried to befall the colony, and also an honor to Massasoit, that the Pilgrims stood firm in their alliance to the Pokanokets.

But the alliance was bound to be broken when more English settlers arrived and the colony grew. The Native Americans' land was increasingly

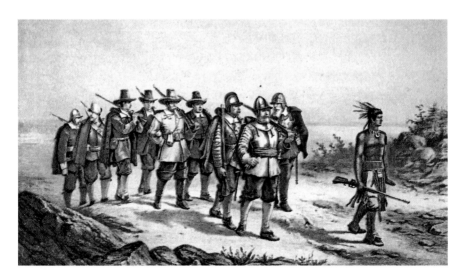

Postcard of J.E. Baker's lithograph of *The March of Myles Standish*, depicting Hobbamock leading the captain and his Pilgrim warriors to Wessagusset. *A.S. Burbank, Plymouth, Massachusetts.*

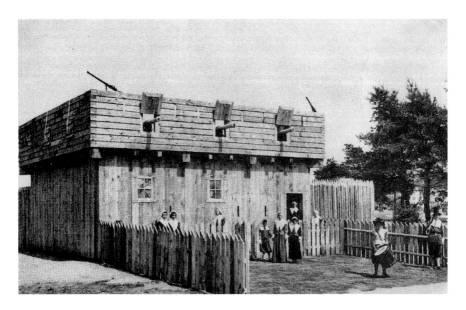

Vintage postcard of a replica of the Pilgrims' First Fort and Meetinghouse at Plimoth Plantation. *Courtesy of Plimoth Plantation.*

being seized, and disease was being spread throughout their communities. It was inevitable that skirmishes between the tribes and colonists happened, and full-fledged war was at hand.

Plymouth was not exempted from King Philip's War despite the previous peace of fifty years. The historical representation of that peace, circa 1627, is on full display today at Plimoth Plantation during the months of March through December. At the site, visitors can see the re-created seventeenth-century Pilgrim village and interact with actors interpreting the lives of the *Mayflower* passengers. Wampanoag descendants interpret the Wampanoag Homesite of the same period and demonstrate how the Native people lived for centuries on that very land.

In addition to the seventeenth-century villages, Plimoth Plantation offers the community an array of enriching cultural experiences all year long, including events, lectures and first-run independent and foreign films at Plimoth Cinema.

What visitors to Plimoth Plantation may not realize is that they may be parking their car or disembarking from a motor coach on one of the bloodiest and most violent spots in Plymouth. Halfway between the Pilgrim Village and the Wampanoag Homesite is the site of a massacre that occurred on March 12, 1676, during King Philip's War.

There stood William Clark's Garrison House at the Eel River. War was raging all around Plymouth Colony, yet Clark's garrison was considered to be one of the safest places of refuge for the English citizens. But safe it was not, and that house fort was the site of the brutal massacre of eleven women and children during King Philip's War.

Of all the tragedies of the seventeenth century, one stands out as a final, irreparable blow to the peace forged by the Pilgrims and the Pokanokets, and it happened in the span of one generation. That is the fate of King Philip, also known as Metacomet.

King Philip was the son of the Pilgrims' ally, Sachem Massasoit. He and his brother Alexander, also known by his given name Wamsutta, took on English names to help preserve the peace that their father had so delicately constructed.

Diplomacy ruled in the treaty between Massasoit and the Pilgrims, but it failed completely by 1675. One of the most violent and destructive wars in American history, King Philip's War was primarily waged within the confines of southern New England, from Massachusetts south and west and into Rhode Island. In the war, some native factions sided with and fought alongside the English against Philip and his native allies.

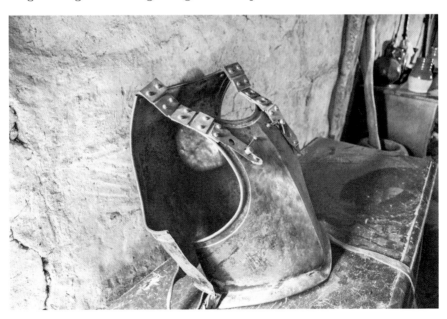

Reproduction armor similar to what would have been worn by Captain Myles Standish in the seventeenth century. *Patrice Hatcher Photography. Courtesy Plimoth Plantation.*

The English were accustomed to decapitation and impalement of criminals and enemies of war. It was a practice that had been going on for centuries in Europe and one that the Pilgrims brought with them to Plymouth Colony. Both the colonists and Native Americans were doing it by the time of King Philip's War.

Edward Lodi wrote in his book *Ghosts from King Philip's War:* "Among the Indians, there was a belief that if the body was not intact at burial, the spirit of the dead person could not properly rest after death. Separating body and head and placing them in different locations was therefore an added punishment to whatever tortures might have been inflicted before death."[11]

The war ended when King Philip was brought back to Plymouth in pieces. His last stand had him watching over Town Square for twenty years, literally.

It was in Bristol, Rhode Island, that Philip met his end on August 12, 1676. A bullet shot by a Pocasset Christian Indian named Alderman pierced his heart in a battle led by Colonel Benjamin Church. Philbrick provides a graphic description of the desecration of Philip's body following his death:

> *Church gathered his men on the rise of land where the Indians' shelter had been built and told them of Philip's death. The army, Indians and English alike, shouted "Huzzah!" three times. Taking hold of his breeches and stockings, the Sakonnets [Native Indians] dragged the sachem's body through the mud and deposited him beside the shelter—"a doleful, great, naked, dirty beast," Church remembered. With his men assembled around him and with Philip's mud-smeared body at his feet, Church pronounced his sentence: "That for as much as he had caused many an Englishman's body to lie unburied and rot above ground, that not one of his bones should be buried."[12]*

It was not Church or any Englishman who would do what was to come next, but another Native American: "The Sakonnet took up his hatchet, but paused to deliver a brief speech. Philip had been a 'very great man,' he said, 'and had made many a man afraid of him, but so big as he was he would now chop his ass for him."[13]

King Philip was drawn and quartered. Church gave one of Philip's hands to his assassin. He brought his head to Plymouth and presented it to the townspeople just after their prayer services:

> *[O]n Thursday, August 17, Pastor John Cotton led his congregation in a day of Thanksgiving. Soon after the conclusion of public worship that*

day, Benjamin Church and his men arrived with the preeminent trophy of the war. "[Philip's] head was brought into Plymouth in great triumph," the church record states, "he being slain two or three days before, so that in the day of our praises our eyes saw the salvation of God." The head was placed on one of the palisades of the town's one-hundred-foot-square fort, built near where, back in 1623, Miles Standish had placed the head of Wituwamat after his victory at Wessagusset. Philip's head would remain a fixture in Plymouth for more than two decades, becoming the town's most famous attraction long before anyone took notice of the hunk of granite known as Plymouth Rock.[14]

Today there is a memorial to King Philip in Town Square, a few hundred yards from where the fort and his head were located. It is a simple granite rock with a plaque embedded into it. It reads:

Metacomet (King Philip)

After the Pilgrims' arrival, Native Americans in New England grew increasingly frustrated with the English settlers' abuse and treachery. Metacomet (King Philip), a son of the Wampanoag sachem known as the Massasoit (Ousamequin), called upon all Native people to unite to defend their homelands against encroachment. The resulting "King Philip's War" lasted from 1675–1676. Metacomet was murdered in Rhode Island in August 1676, and his body mutilated. His head was impaled on a pike and was displayed near this site for more than 20 years. One hand was sent to Boston, the other to England. Metacomet's wife and son, along with the families of many of the Native American combatants, were sold into slavery in the West Indies by the English victors.

United American Indians of New England

The United American Indians of New England has held a National Day of Mourning in Plymouth each Thanksgiving since 1970.

Near the site of the marker, strange phenomenon has been reported, including unusual weather, falling trees and general malaise. Is King Philip still watching over Town Square, seeking revenge for his murder and his body's desecration? Was King Philip a victim of a curse? Is the land of the Patuxet, the Land of the Little Falls, cursed? Is Plymouth cursed?

2
PLYMOUTHEANS

PLYMOTHIAN
(also Plymouthian, Plymouthean, Plymothean)

NOUN:
*A native or inhabitant of Plymouth in Devon, or of any of the towns or cities
called Plymouth in the United States.*

ADJECTIVE:
Of, belonging to, or relating to a town or city called Plymouth or its inhabitants.

ORIGIN:
*Mid-17th century; earliest use found in Massachusetts. Partly from the name
of Plymouth + -ian, and partly from Plymouth, the name of several towns and
cities in the United States, especially Plymouth in Massachusetts + -ian. With
forms in -ean compare -ean.*

PRONUNCIATION:
Plymothian/ˌplɪ ˈmaʊθɪən// ˌplɪ ˈməʊðɪən// ˌplɪ ˈmuːðɪən[15]
Source: Oxford Living Dictionaries, Oxford University Press, 2017

Pedigree is important to New Englanders. Boston has its Brahmins. Cape
Cod has it Cape Codders, Locals and the Old Comers (the name used
for *Mayflower* descendants who moved back to the Cape after that fateful

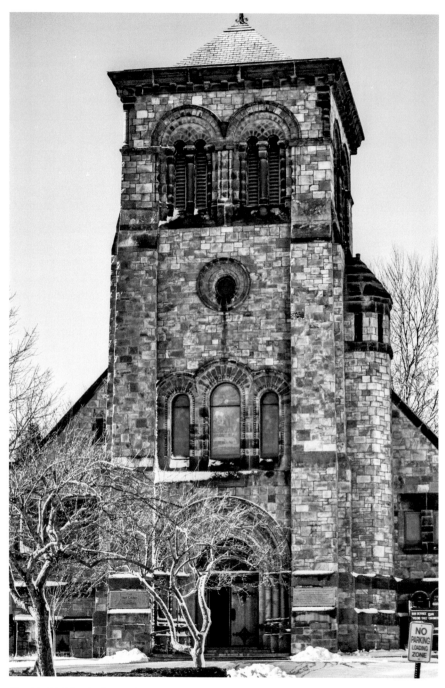

First Parish Meetinghouse (1899) at the foot of Burial Hill in Town Square. It is the oldest continuously operating church congregation in the country and is the sixth of the "Pilgrims'" church buildings, beginning with the First Fort. *Patrice Hatcher Photography.*

first landing in the fall of 1620). And Plymouth has its First Comers and Plymoutheans (I will use this spelling, as it is regularly used by the editors and writers of the *Old Colony Memorial*, Plymouth's nearly two-hundred-year-old semi-weekly newspaper).

Plymoutheans are people who were born in Plymouth. Make no mistake, they are not people from Plymouth, nor are they people who reside in Plymouth or who moved to Plymouth because their family lives in Plymouth. They are people born in Plymouth at home or at the Jordan—Jordan Hospital, that is—which, through a merger with Beth Israel Deaconess Hospital in Boston, now goes by the name BID-Plymouth. But it will always be the Jordan to Plymoutheans. And, yes, it is named for Eben Jordan of Jordan Marsh and Company fame, for those who remember the spectacular fashions and blueberry muffins of the Boston-based department store destination extraordinaire.

Plymoutheans relish their traditions. As one would imagine, Thanksgiving is big in Plymouth. One and a half million people from around the world come to Plymouth every year, with estimates of more than a quarter of a million of them visiting in the autumn in celebration of the Pilgrims, the Wampanoags and Thanksgiving.

America's Hometown Thanksgiving Celebration has the town bursting at its seams. During the weekend preceding Thanksgiving, every hotel room is booked, every parking space is taken and people come from far and wide to enjoy a weekend of festivities that include the second-largest Thanksgiving parade in the country, the New England Food Festival, a reproduction historic village, a Wampanoag pavilion, patriotic-themed concerts honoring veterans and members of the armed forces featuring military bands and the nation's premier drum-and-bugle corps brigades and educational and cultural activities galore.

America's Hometown Thanksgiving Celebration showcases much of the historic downtown. The parade takes a direct southerly route through the main thoroughfare of Plymouth, beginning in North Plymouth on Court Street and continuing on as Court Street changes names at Shirley Square to Main Street and then to Main Street Extension, and then to Sandwich Street. After crossing Town Brook on the World War I Veterans Memorial Bridge, the parade takes a left turn at Water Street and winds itself to the waterfront, past the 1957 replica *Mayflower II* docked at the State Pier and on to the reviewing stand at Pilgrim Memorial State Park. Thousands of spectators perch across from the reviewing stand on historic Coles Hill, site of the first Pilgrim burial ground. But that's a story for another chapter.

As big as Thanksgiving is on the worldwide stage as America's holiday, and as central as it is for Plymouth visitors and the regional tourism industry, Plymoutheans' big day is Forefathers' Day. This is the anniversary of the day the Pilgrims landed and disembarked at Plymouth Rock, which was December 11, 1620. "Was" is the consequential word here. Today, that anniversary is celebrated on December 21 and/or December 22, depending on whom you ask. Why the "and/or"?

Forefathers' Day was first recognized by members of the Old Colony Club in its founding year of 1769. This venerable gentlemen's club in Plymouth is the oldest of its kind in the country. Meetings mix fellowship with tradition and history in a historic house located at the corner of Court and Brewster Streets.

Forefathers' Day is the members' New Year, commencing with a parade and a cannon fire atop Coles Hill (one, two or three catapulting explosions, depending on the ruling authority in the club at the time). Early risers can witness this ritual themselves each December 22, the first day after the winter solstice, when top-hatted and top-coated club members march to the hill from their stately, hedged headquarters that is open to no one but themselves. (Membership in the club is restricted to men. Women are allowed in from time to time for social events as guests of members, for example, wives or significant others of members.)

Their parade culminates at daybreak, when they blast their cannon across the harbor toward Plymouth Rock. It is a unique and moving experience—not to mention alarming when the mighty but small and formidable mortar blasts across one of only two north–south byways in Plymouth.

The town is the most expansive settlement in the Commonwealth of Massachusetts. According to the U.S. Census Bureau, the total area of the town is 134 square miles, of which 96.5 square miles are land and 37.5 square miles are water.

What happens here is according to and strictly adhering to tradition. The firing of a cannon from a hill toward the harbor by some of the town's most prominent citizens is, well, considered something to be part of.

But, again, why the difference in dates? Here is the short explanation, courtesy of the Old Colony Club website:

> *In December of that year* [1769], *they decided to hold their annual meeting on the anniversary of the December 11, 1620, Landing on Plymouth Rock. This celebration, originally referred to as "Old Colony Day" and later as "Forefathers' Day," was first observed on December 22, 1769....*

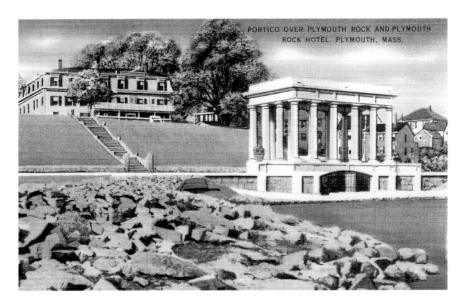

PORTICO OVER PLYMOUTH ROCK AND PLYMOUTH
ROCK HOTEL. PLYMOUTH, MASS.

Vintage postcard of portico over Plymouth Rock, with the former Plymouth Rock Hotel in the background atop Cole's Hill. *Smith News Store, Plymouth, Massachusetts.*

The December 22nd date was chosen to adjust to the discrepancy between the Julian or Old Style and the Gregorian or New Style calendars.... When England and the colonies finally did accept the new system in 1752, eleven days had to be added to make the adjustment. With this recent event in mind, the Old Colony Club converted the Landing anniversary to December 22. Unfortunately to adjust a date for the early 17th century it was only necessary to add ten days, since the two calendars had not yet diverged by eleven days as they had in 1752.[16]

Since the Pilgrim Hall Museum was established in town in 1824, the Forefathers' Day Dinner has been held every year on December 21. Well-known speakers of national and international merit—U.S. Supreme Court justices, including the Honorable Stephen Breyer; statesmen, including former secretary of state, U.S. senator and U.S. representative Daniel Webster; Massachusetts governors, including Deval Patrick; diplomats from the British embassy; Harvard academics, including Peabody Award winner Dr. Henry Louis Gates Jr.; and former executive director of the Boston Museum of Fine Arts, Malcolm A. Rogers—are invited to headline the commemorative beatification of the Pilgrim Landing, with members of both the Pilgrim Society (the membership society of Pilgrim

Hall Museum) and the Old Colony Club attending both commemorations, despite their agreeing to disagree about the date of Forefathers' Day.

Eternally missing from every Forefathers' Day event is the late and great Reverend Peter J. Gomes. A Harvard theologian, Baptist minister, orator, teacher, author and former executive director of Pilgrim Hall Museum, Peter was first and foremost a son of Plymouth. He was the guiding light and chief celebrant of Pilgrim Hall Museum and Forefathers' Day for more than fifty years, beginning when Pilgrim Society president Rose Briggs took him under her wing in the 1950s. For Plymouth and surrounding hamlets, it truly is a day (or two) of the town's equivalent of the Academy Awards, Tony Awards, Grammy Awards, American Music Awards and Academy of Country Music Awards combined.

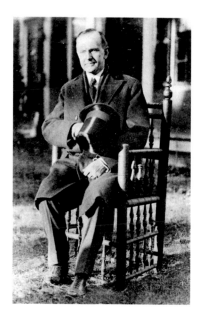

President Calvin Coolidge when he was Massachusetts's governor in Governor William Bradford's chair during the Pilgrim tercentenary on Forefathers' Day, December 21, 1920. *A.S. Burbank, Plymouth, Massachusetts; Underwood & Underwood, New York.*

But it is also confusion rooted in tradition, as scrupulous attention to historical accuracy makes Forefathers' Day so unique. Frankly, that is how the date for Forefathers' Day was determined, and it is not unlike the Pilgrims' epic and fateful voyage four hundred years ago. It began with two ships, the *Mayflower* and the *Speedwell*, with a destination of Virginia. The leaky *Speedwell* was abandoned at Dartmouth Harbor in England. A storm took the *Mayflower*, now double-booked with the passengers of two vessels, to the wrong place. It was not Virginia where other Englishmen would greet them, but a fierce and barren landscape of sand. Legally, it would take a year for the Pierce Patent to become effective, allowing the Pilgrims to settle in a new England, on their own, after much confusion and muddle.

So, there are two dates on which you can celebrate Forefathers' Day in Plymouth, occurring consecutively and approximately fourteen hours apart.

The first is December 21, beginning at 4:00 p.m., when the Pilgrim Society holds its annual meeting, voting in members as trustees to lead Pilgrim Hall Museum in historical and cultural exertions, including fundraising.

Pilgrim Hall Museum is America's museum of Pilgrim artifacts. No matter whom you descend from—passengers of the *Mayflower*, Native Americans or immigrants from across the world—as an American, you can identify with the Pilgrim story. Simply put, our shared history as Americans is on display year-round at 75 Court Street at Pilgrim Hall Museum.

After the meeting, the dinner commences at Hotel 1620 (formerly the Radisson Inn & Suites and formerly the Sheraton Four Points), when succotash is served and the revels continue into the late evening hours, finally culminating with the traditional singing of the hymn "The Breaking Waves Dashed High" by Felicia D.B. Hemans:

The breaking waves dashed high
On a stern and rock-bound coast,
And the woods against a stormy sky
Their giant branches tossed,
And the heavy night hung dark,
The hills and waters o'er,
When a band of exiles moored their bark
On the wild New England shore.
Not as the conqueror comes,
They, the true-hearted, came;
Not with the roll of the stirring drums,
And the trumpet that sings of fame.
Not as the flying come,
In silence and in fear;
They shook the depths of the desert's gloom
With their hymns of lofty cheer.
Amidst the storm they sang;
And the stars heard, and the sea!
And the sounding aisles of the dim woods rang
To the anthem of the free.
The ocean eagle soared
From his nest by the white wave's foam,
And the rocking pines of the forest roared,—
This was their welcome home!
What sought they thus afar?
Bright jewels of the mine?
The wealth of seas, the spoils of war?
They sought a faith's pure shrine!

Vintage postcard of the Pilgrim Society & Pilgrim Hall Museum on Court Street in Plymouth, early 1900s. *H.A. Dickerman & Son, Taunton, Massachusetts.*

Ay, call it holy ground,
The soil where first they trod!
They have left unstained, what there they found:
Freedom to worship God.[17]

The second date is December 22, when the Old Colony Club holds its daybreak parade and cannon-fire festivities on Coles Hill.

Many credit the Plymouth Antiquarian Society as being founded by Plymouth's ladies of privilege in response to the Old Colony Club. The antiquarian society was not founded until 1919; regardless of its origins, the society and the history it interprets is of utmost importance to the historical fabric of Plymouth, beyond and in concert with the Pilgrim story.

There are three historic properties owned and lovingly cared for by the Plymouth Antiquarian Society: the 1677 Harlow House, the 1749 Spooner House and the 1809 Hedge House. The antiquarian society also oversees an ancient Native American site, Sacrifice Rock. Each of these sites, open seasonally, is a magnificent representation of three centuries of life, architectural history and material culture in Plymouth.

Two of the houses stewarded by the Plymouth Antiquarian Society are haunted.

Let's start with the Spooner House on North Street, one of Plymouth's most haunted streets. The Spooner House was built in 1749 for Hannah Jackson. But it is not Jackson who haunts one of the oldest standing houses in Plymouth. Instead, the story goes that the house is haunted by little Abigail Townsend, an eight-year-old girl who died from a tooth infection in the upstairs right bedroom of the home in the mid-1700s. Reportedly, Abigail skips rope outside in the alleyway, welcomes workmen to the house, appears in windows and even visits her twenty-first-century neighbors.

Vicki Noel Harrington is the owner of Spirit of Plymouth Walking Tours of America's Hometown (www.spiritofplymouth.com), a year-round tour company featuring costumed guides who bring history alive through historically accurate stories and tales of yore. Vicki is also a docent at the Plymouth Antiquarian Society properties. She has served in that role for six years and was eager to share her experiences at the Spooner House.

"For all we talk about ghosts and the stories about the alleyway that are shared during walking tours, I have never seen anything in that house or in the alley that would support the most famous ghost story associated with the house, that of a little girl ghost," said Vicki.

The legend of Abigail Townsend derives from a reading by a psychic who perceived a child spirit sharing that name.

"We know no little girl named Abigail Townsend ever lived in that house. It's been researched," she said. "I have never felt or even sensed a child in the building. Not that I am psychic, but I will pick up on feelings, and I have never sensed a child in that house."

Vintage postcard view of North Street facing east toward Plymouth Harbor. *A.C. Bosselman & Co., New York.*

"That being said, you just sort of feel like you are not alone on occasion," she added. "I have put my phone on record to check for EVPs [electronic voice phenomenon]. Nothing."

The first Spooner to live in the house was Deacon Ephraim Spooner, a merchant and Patriot during the American Revolution. Two hundred years of Spooners occupied the home between Deacon Spooner and the last family member to live in the house, James Spooner. In the 1950s, James bequeathed the family home and its contents to the Plymouth Antiquarian Society for the purposes of turning it into a museum.[18]

James Spooner was a lifelong lover of music, and his Victrola and records remain in his parlor. The record that is on the Victrola today was one of James's favorites, *Air with Variations* by Handel. Perhaps testing fate, or being mischievous during a lull between tours, Vicki tried to bring out the spirit of James by playing a recording of the Handel piece on her phone.

"Nothing," she said. "Nothing happened."

There was one event that occurred while giving a tour that did cause Vicki some pause.

"A woman came to Plymouth on her honeymoon and made a special visit to the house because she is a Spooner descendant. She had visited the house a lot as a child with her grandmother, who was from nearby Acushnet," Vicki explained. "But she was not sure which branch of the Spooner family she descended from."

"I looked up at the portrait of Nathaniel Spooner," she continued, "and the resemblance was uncanny. She was the female version of Nathaniel!"

"Looking at that portrait, I just knew she had to be his descendant. At that moment, a chill ran up my spine, a cold breeze blew through the house," Vicki said. "It was summertime, and that house is always hot in summertime. When the visitor got to the portrait, she spotted a spyglass and pocket watch in the painting. A few years back a man from Pennsylvania toured the house, and he had the pocket watch from the painting with him! She called out, 'That's my uncle's pocket watch!' It was unmistakable. She descends from Nathaniel."

Vicki is a very experienced and knowledgeable historian and tour guide, having also led tours for Plymouth's popular tour company, Colonial Lantern Tours, before the owners of the company retired and shuttered the business. Featured on the Travel Channel, Colonial Lantern Tours offered guests an evening experience of thrills, chills, legend and lore while lighting their way with authentic punched-tin colonial lanterns.

"This particular evening, I was leading a tour of about one hundred high school aged students from Indiana," Vicki said. "We would tell people on

the tour that if their lantern went out, a ghost would follow them home, so I asked the kids to be aware of anything happening."

"At the end of the tour, they got on their buses, and I wished them well, and I told them not to take a ghost home with them," she continued. "It was a quiet tour, and a nice group of kids."

"I noticed a group of girls elbowing one of their friends, trying to get her to talk to me," said Vicki. "To reassure her, I said, 'I'm not going to think you are crazy, I do this for a living. What happened?'"

Vicki explained, "The girl said, 'When we started the tour, before you told us any stories about the Spooner House, I saw a woman in the window with a bob haircut and a lace scarf.'"

"I asked her, 'Did you see a girl ghost?'"

"'No, it wasn't a girl ghost, it was a woman,' said the girl."

Vicki thought about it for a while and came to the conclusion that it could have been the ghost of Sophronia Spooner, also known as Frona.

She said, "Frona was from Concord, New Hampshire. She died in the 1930s and was the last woman to live in the Spooner House. She was very traditional, and never let her skirt hems rise in the 1920s, when everyone else became flappers."

"The window where the girl on the tour saw Frona would have been James's room." Vicki continued, "The shades should have been pulled down in that room, because that's one of my jobs as a docent. Before locking up the house, docents pull down the shades and attend to other housekeeping activities."

"I didn't think too much about it until the next time I went into work that Sunday at the Spooner House, and there was the portrait of Nathaniel, with his hair swooped loosely back wearing a lacy jabot. I looked at him, and I said 'You were in the window last night,' and a chill snaked up my spine. 'It was you!'"

Vicki explained Nathaniel's story. She said, "He was not born at the Spooner House, nor did he die there, but he grew up there after being taken in by Elizabeth and Ephraim when he was about eight years of age. They took him in after they lost their first five children and raised him as their own. Nathaniel learned the family business and became a ship captain."

"He's there at the Spooner House. It has got to be him," declared Vicki. "His son Bourne founded the Plymouth Cordage Company. Nathaniel's portrait is of him as a ship captain. It wasn't Frona at all, but Nathaniel peering out the window at the tour of kids from Indiana."

Plymouth Antiquarian Society docents, specially trained historical interpreters and guides, are educated in all manner of housekeeping for the antique homes they interpret. Certain protocols are followed by every

member of the visitor services staff. Opening and closing the houses, conducting a tour group through the house—every docent performs the same duties in the same manner every day.

"In the summer of 2016, the upstairs bedroom door on the northwest corner of the house, which is on the alley side of the house, opened on its own, two or three times," said Vicki. "Now, you really have to yank that door to make sure it is closed. It's a stubborn door, and all of us docents know how to make sure it is closed. We wouldn't leave the door open."

She added, "Another time, the books in the study were not stacked in the usual manner. 'Plymouth Charades' is always on the top of the stack of books. It's always on top, but I went in there one day and it was not on top! Did someone else move the book when dusting? Maybe, but the director has us pretty well trained not to touch anything, even when you are dusting. Everything inside the house is an artifact, part of the house museum's collection. You dust around the artifacts carefully, and you never move them."

At this point in our tale of the Spooner House, let us revisit the Abigail Townsend story. Every ghost tour in Plymouth tells the same story: if you knock on the alleyway door of the house, you will be let in. There is a familiar and timeworn legend that painters working on the restoration of the Spooner House knocked on the door and were let into the house by a little girl. Did that happen? Who were the painters? Is it true?

It's a good story, but it is nearly impossible to verify. No one from the Plymouth Antiquarian Society will confirm the account. Chalk it up to legend, perhaps.

But what of the source of the story of how the little girl ghost was given a name and a cause of death? Years ago, a medium visited the alley next to the Spooner House. The story goes that the medium said, "There is a little girl here who haunts the alley, the house and the back garden. Her name is Abigail Townsend and she died between the ages of eight and ten of an infected tooth. It was in the early 1800s."

Rumor has it that a different psychic came along and described the same girl but said she died from a severe case of the mumps.

When asked about this psychic evidence, Vicki replied, "A puffy face? I have had enough people tell me that they have seen a girl with a puffy face in the window. I've never seen it; however, if someone knocks on that door in the alley, the shade in the upstairs window moves. Somebody looks out the window to see who is in the alley. This happens 70 percent of the time when someone knocks on that door."

Alleyway next to Spooner House facing North Street. *Patrice Hatcher Photography.*

"Last year, we replaced the shades with a stiff, heavy fabric, but the shade in that window still moves." She added, "I've seen it move. Not a lot happens in the house but after six years as a docent, I know when the shades move, and I have seen the shades move."

Vicki has spent countless hours researching if an Abigail Townsend could have been at the Spooner House at any time during the home's history. "In researching the records, I have found an Elizabeth Townsend who died in the right time period in the area, but she was from Worcester, and her death was recorded in Worcester. Interestingly, her mother's maiden name was Warren [see chapter 5 on Mercy Otis Warren], so she could have been visiting in Plymouth and died, and her family could have taken her home to Worcester and registered her death there." Vicki added, "A lot of people lived in that house. Every family has skeletons in the closet and a juicy story or two, but it just doesn't seem like the Spooners or anyone who resided in the house stirred up controversy."

A few years back on Halloween, the antiquarian society held a séance at the Spooner House. As much as the society staff and trustees frown on bringing the wrong kind of attention to their properties, this particular year the séance was held as a fundraiser for the organization. The event sold out. The interest was far greater than anyone could have imagined.

What was discovered during the séance? Probably not what one docent wanted anyone to know.

In the northeast corner of the house, in what was James Spooner's room, a medium led the séance. Just prior, the medium was given a tour by one of the more experienced and knowledgeable docents, as a courtesy and to give her the lay of the land of the house—but not to give her any inside information. Before sitting down for the séance, the medium asked the guide, "Jimmy wants to know why you were napping on the floor and not on a perfectly good sofa."

Astonished, taken aback and embarrassed, the docent came clean about having taken a nap in James Spooner's room one day. It was brave to own up

to sleeping on the job. She would never have sat on, or even dreamed about sleeping on, an artifact like one of the sofas in the house, so she chose the floor. Her boss was in the room, but truth be told, "Jimmy" must have seen her, and he called her out!

According to Vicki, "During the séance, the medium said that there is not one little girl but two in the house. Elizabeth Townsend and Abigail, maybe the medium got the Townsend name right and transposed the first names. When she said there were two little girls in the house, the EMF went off."

"James is also a common name, like Elizabeth and Abigail," said Vicki. "Is it easy for people to think they have heard those names come through in a séance? Maybe."

"But one thing I do know is that I have seen the wooden shutters open and the shades wave, and I know where the heat registers are in the Spooner House, and they are not in those places," she added.

"On one tour, we had a group of people who had just been to Sam Diego's Mexican Cookery and Bar for dinner. Maybe it was the margaritas that gave one young lady on the tour a dose of liquid courage, I don't know," Vicki joked. "But, when we were outside of the Spooner House, this particular young lady shouted out 'No [expletive] little girl is going to scare me!' and boom! The shade upstairs snapped up!"

Sam Diego's Mexican Cookery and Bar, located on Main Street in Plymouth, is also reported to be haunted. That story will be covered in another chapter.

"That was a very active paranormal tour because, after it, one of the men who worked with us said a little girl ghost got in the car with him and followed him home," she said. "He told us he drove back to Plymouth, opened his door at the Spooner House and said 'Abigail, you gotta get out of here and go home.'"

Patrice Hatcher, psychic, photographer and interior designer, used to own Ishtar's Avalon on North Street, which later moved to 65 Main Street in Plymouth. Her shop and practice was dedicated to psychic and spiritual exploration and tarot card readings, and she sold items related to rituals, runes and stones. Patrice also sold sterling silver jewelry and custom framed artwork.

Having lived in Florida for a number of years, Patrice had become accustomed to all the benefits of living in a climate with warmer weather and was adverse to the New England nuisance of rain, sleet and snow, which she had grown up with. "When it snows, I will say to people, 'I'll make the muffins and coffee while you shovel the snow,'" said Patrice. "'When you are

finished, come on in for muffins and coffee, and relax.' I was so grateful for the help."

"A strange thing would happen, though, in front of Ishtar's Avalon when we were located on North Street. As a business owner I was required to remove the snow and ice on the sidewalk in front of my business," she said. "To minimize the snow accumulations, as if I could, I would always cast my hand out the doorway and across the entrance and say, 'No snow, no snow, no snow here,' and an interesting thing would happen. Where I had cast my hand with the swing of my arm, there would be an arc way of clear sidewalk. No snow, no ice, just a clear area in an arc formation in front of Ishtar's Avalon, just where I had cast my arm while saying 'No snow.'"

"North Street itself has some very funky, interesting energy," Patrice continued. "I would sit at my shop and watch people walking up and down the street going about their daily business. They weren't real people, they were the memories of people. Gray people, just going about their daily business in the center of town, walking up and down North Street, taking the corner at Main Street and going to the harbor, then coming back up the street again."

"The funny thing is, every time I have been on North Street, I find myself looking up at the top left corner of the Spooner House," she said. "I have never seen anything, and I don't know why, but I have felt an energy, an unknown energy, something that knew I was there, but I can't put my finger on it."

Patrice continued, "I never felt that a little girl was there, ever. But something always makes me look up and I don't know why. I always thought it was interesting that there was an energy there. I know people say a little girl has let them into the Spooner House, but I have never seen anything."

As previously mentioned, the Plymouth Antiquarian Society is charged with the responsibility and stewardship of the 1677 Harlow Fort House, the much-heralded 1749 Spooner House and the 1809 Hedge House. Accounts detail the reported hauntings of the Spooner and Hedge Houses, but little is reported of the Harlow Fort House, an outpost in the wild and rugged Plymouth landscape of late seventeenth-century New England. Today, the Harlow House and its beautiful gardens and grounds are the site for the society's annual summer breakfast. It's a picnic with delicious cakes and muffins and exhibits and displays of wool carding and yarn spinning. It is quintessentially New England, with costumed interpreters and tours of the house.

"The Harlow House, I have never been in it. For some reason I can't go in it," Patrice said. "I can't get past the door. I've never gone in, I have never had a bad feeling but for some reason, I just can't get through that door."

Which leads us to the Hedge House, the second haunted antiquarian society property. Who or what haunts the Hedge House? A ghost cat.

A brief history of the Hedge House is as follows, according to the Plymouth Antiquarian Society website:

> *The 1809 Hedge House is one of Plymouth's finest examples of Federal period architecture, featuring octagonal rooms in the main block, and a rare, intact carriage house. Built by sea captain William Hammatt, the house was originally located on Court St., where Memorial Hall is today. In 1830, merchant Thomas Hedge purchased the house and added a three-story ell to accommodate his large family.*[19]

The Hedges owned a Main Street store, a waterfront counting house and "Hedges Wharf," the latter famous because embedded in its surface was Plymouth Rock, thought to be the landing place of the Pilgrims. Thomas Hedge was one of Plymouth's early industrialists and entrepreneurs, investing in the town's first whaling ventures, building a candle factory to process whale oil and partnering with his brother Isaac in a brick manufactory. For a time, the Hedge family lived in Boston and used their Plymouth house as a summer home.

The house was lived in by Hedge family members until the death of the last resident, Lydia Hedge Lothrop, in 1918. Threatened with demolition to clear the way for the construction of Memorial Hall, the house was rescued by the Plymouth Antiquarian Society, which bought the house for one dollar in 1919 and arranged to have the building moved to Water Street.[20]

Bricks were a huge business, and the Hedges made most of them. Hedge bricks can be seen in nearly every building constructed with bricks after 1850. You may even have them in your home. They are everywhere.

"When I was twenty one years old, I bought a house in nearby Carver. I would go to Plymouth to play 'tourist for the day,'" said Patrice. "I did all the fun tourist things that everyone should do. Back then, the Hedge House was decorated in the 1830s period, when the merchant Thomas Hedge lived there. It was called the Antiquarian House then. Now it is decorated to a later time period."

"Nobody else was there but me and the docent. She gave me an amazing tour," said Patrice. "She took me beyond the 'velvet rope' and into rooms you couldn't go into then. She showed me artifacts and let me pick up things. It was a wonderful experience. She was absolutely lovely."

"However," she continued, "there are places in that house that feel odd. There is a staircase that feels odd. I was recently there when they did their

'Hats on Parade' fundraiser. The staircase that connects the main house to a back part feels peculiar."

As referenced previously, the Hedge House was moved from its original location on Court Street to make way for the construction of Plymouth's Memorial Hall. It was purchased by the Plymouth Antiquarian Society in 1919 and moved to Water Street shortly thereafter.

"I was visiting the Hedge House again with a friend, and we both noticed it. It was the weirdest feeling on the planet," Patrice said. "It was where there is a step down into another room. It almost felt like you were stepping into another place, and like it was completely disconnected from the house."

"I have never been inside the carriage house," she continued. "The carriage house in itself is very odd. Things catch your eye and you look and then they are not there. There is something there. It's almost as if they are trying to catch your attention and as soon as they have it, they walk away."

As a Plymouth Antiquarian Society docent, Vicki Noel Harrington has led her fair share tours at Hedge House and seen things that cannot be explained. "I volunteered for the Hearth and Home Tour one year," she said. "It was a house tour type of fundraiser where people bought tickets and toured private residences in Plymouth with fantastic kitchens. It was when volunteering for this house tour when another volunteer asked me if I had seen the ghost cat."

Vicki had.

"I was sitting on the front steps of the Hedge House, inside reading my book, waiting for people to come for a tour," Vicki said. "All of a sudden, I saw a black-and-white cat out of the corner of my eye dart across inside the inside foyer. At first I thought, 'No, I didn't see that. Someone planted that idea in my head.' Or so I thought."

"Then, we were doing an event at the Hedge House and I was walking through the keeping room to go to the front door and there was a cat sitting under the table!" She continued, "I saw a cat, a long-haired tortoiseshell cat, and I thought, 'Cute cat!' Then I realized there is cat in the house! Oh no, what could this cat do to the furniture, the floors, the fur. It could destroy the artifacts in the house! So I turned around to grab it, and it was gone. If it had left, it would have had to run by the director, and she said nothing."

When asked her thoughts on whether she thought a cat was haunting the Hedge House, Patrice Hatcher replied, "It's not a big surprise to me that a cat is haunting the house. A lot of animals come through."

Plymoutheans love their heritage, their rituals, their traditions and their culture. Apparently, so do their pets. They tend to hang around awhile.

3

BURIAL HILL

Since 1620, Plymouth's Burial Hill has been central to the residents of Plymouth. The view from its highest point is magnificent. The Pilgrims built their Fort House and, later, their Meetinghouse at its base and buried some of its members there. Its current residents include William Bradford, William and Mary Brewster, Mercy Otis Warren and the crewmen of the *General Arnold*, with its last occupant being interred in 1957. There is much paranormal activity at Burial Hill, from orbs to full-body apparitions.

Before we get into the thick of the hauntings that reportedly occur at Burial Hill, I would be remiss if she did not remind the reader that Burial Hill is a cemetery first. The grounds, walkways, trees, headstones, monuments and remains themselves should be treated with respect and care. Many of the headstones are invaluable and irreplaceable. They are rare, historical artifacts documenting our nation's social, cultural, folk art and craft and anthropological history. The headstones are also some of the best examples of gravestone art in the United States.

The Friends of Burial Hill, a nonprofit volunteer group of concerned citizens founded in 2010, is committed to the conservation of the headstones. The group leads workshops and tours to further efforts at preservation and conservation. Its hard work and dedicated efforts to preserve this national treasure led to Burial Hill receiving one of the highest historical achievements in the country. In 2013, the cemetery was named to the National Register of Historic Places.

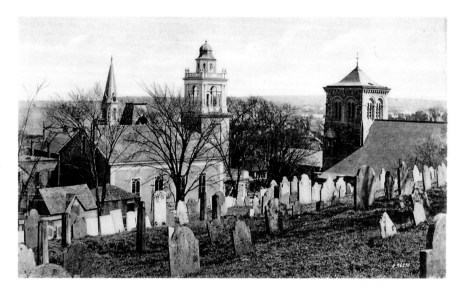

The view from Old Burial Hill looking east toward Plymouth Harbor. *A.S. Burbank, Plymouth, Massachusetts.*

The Town of Plymouth, under its Cemetery and Crematory Management Office, owns and oversees the maintenance and use of the Burial Hill cemetery, as it does all cemeteries in town. On the town website, officials ask visitors, "As you walk through Burial Hill, please remember that this is historic and sacred ground, which deserves care and respect. Many stones have a better chance of survival if they are not touched. We appreciate your cooperation."

Specific rules and regulations govern the use of Burial Hill, including times when visitors are allowed inside the property. Special permits are required for groups and tours to enter Burial Hill and for private citizens to perform any kind of work at Burial Hill or on any of its property.

For a complete list of rules and regulations, as well as information about this valuable historical resource, please visit the Town of Plymouth website, specifically the Burial Hill Cemetery page (www.plymouth-ma. gov/cemetery-and-crematory-management/pages/burial-hill-cemetery). For additional information, contact the Cemetery and Crematory Management Office: 102 Samoset Street, Plymouth, MA 02360; office hours: Monday–Friday, 7:00 a.m.–3:30 p.m.; telephone: 508-830-4078.

At the time of this writing, Burial Hill is also the site of an archaeological dig. Beginning in 2012, a team of archaeologists from the University of Massachusetts–Boston led by David Landon in partnership with Plimoth

Plantation have been working summers at Burial Hill to unearth the original Pilgrim settlement. The goal of the project is to pinpoint exactly where the Pilgrims first settled and to find tangible evidence of how the forefathers and their families lived their everyday lives.

Brian MacQuarrie, a reporter for the *Boston Globe*, reported in an article dated November 23, 2016:

> *Archeologists from the University of Massachusetts Boston said they have discovered what is believed to be part of the original settlement, a conclusion reached through calf's bones, musket balls, 17th-century ceramics, and brownish soil where a wooden post would have stood.*
>
> *The breakthrough occurred on Burial Hill, a rise that includes a centuries-old cemetery where historical lore had long placed part of the first settlement. But archeologists had never dug there before—partly through concerns about disturbing the graveyard—until Landon and his team put together a meticulous, sensitive plan to work on the margins.*[21]

Compelling evidence exists that this is where the Pilgrims settled. The article continues:

> *"What they found this summer—in a 17th-century trash pit and in the stained soil that indicated a post hole—told the team members they were turning the very ground where the first settlers lived. The key to that finding was the discovery of a calf's bones underneath a layer of discarded household artifacts that dated from before 1650," Landon said. "The 102 original Pilgrims and their earliest descendants raised domesticated cattle, unlike their Native American neighbors. So, the discovery of calf remains from that time— as well as a post hole to support a wooden house or structure—is compelling evidence that a sliver of the original settlement existed there," Landon said.*[22]

While most visitors to Plymouth may believe that the Pilgrims' first settlement was on the site of the historical interpretation attraction Plimoth Plantation, that is not the case. Plimoth Plantation is more than three miles north of Burial Hill.

"People have never found part of the seventeenth-century settlement in downtown Plymouth," Landon said. "For the first time, we found part of the built environment."[23]

Not only did the archaeologists find Pilgrim artifacts during the dig, but also, not surprisingly, Native American artifacts. MacQuarrie's article adds:

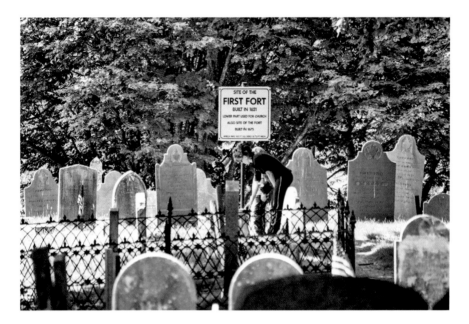

Location of the Pilgrims' First Fort and Meetinghouse on Burial Hill. *Patrice Hatcher Photography.*

"The excavation has shown that Burial Hill also was used by Native Americans before the Pilgrims arrived on a wayward voyage they had thought would take them farther south. The archeologists discovered a stone-tool workshop and pottery on the site, among other Native American artifacts."[24]

Burial Hill's earliest existing grave marker is dated 1681. *Mayflower* passengers, American Revolution Patriots and more than 140 veterans from four wars are among the notable people interred at Burial Hill. According to author Frank Herman Perkins in his 1896 pamphlet "Handbook of Old Burial Hill, Plymouth, Massachusetts," published by Plymouth's A.S. Burbank and Company: "There are about 2,150 headstones on Burial Hill, and many graves are unmarked. In some cases, undoubtedly, this absence of a memorial is due to the considerable cost of stones in the early days. In other instances the monuments have fallen prey to the ravages of time."[25]

Some estimates say that there are over three thousand people buried at Burial Hill.

Orbs, or light anomalies, are the most commonly reported unexplained phenomenon on Burial Hill. Orbs are those luminescent balls of light that sometimes move about or shoot across a camera lens when someone

takes a photo or records a film. Can the multitude of pictures and stories of orbs at Burial Hill be attributed to the fact that thousands of people have visited Burial Hill over the years during nighttime investigative ghost tours? It's always dark when people claim orbs appear on their film or digital screens. Are orbs really balls of energy and light? Are they ghosts, spirits or demons?

Consider the meteorological atmosphere on Burial Hill. It's in Plymouth, which is located in New England. The saying goes, if you don't like the weather in New England, wait a minute and it will change. It's on a hill overlooking Cape Cod Bay, which is part of the Atlantic Ocean. In the early spring, it rains a lot and it is chilly, then loads of pollen spores fall from the trees in late spring. In the summer, it is hot and humid. In the fall, it rains a lot, but sometimes we get an "Indian Summer," when the temperature rises as if it is summer, yet the air is very dry.

In my estimation, orbs can be explained away as many things—dust, moisture, reflection, insects, leaves or pollen. Most probably they are easily caught on camera because they are very common elements that are part of our living world. Also, because they are being captured while amateur ghost hunters are conducting an investigation on a tour, I suggest that, perhaps, these people's imagination might be getting the best of them during the excitement and desire to get "real" evidence of a spirit. Obviously, I am skeptical that orbs are supernatural beings.

Vicki Noel Harrington, owner of Spirit of Plymouth Walking Tours, a veteran guide for Colonial Lantern Tours and a docent at the Plymouth Antiquarian Society, has spent a lot of time on Burial Hill, both at night and during the day. She says she has always been fascinated by ghosts, ever since she saw an apparition at her father's house in Longmeadow, Massachusetts, when she was twelve years old. She said her sister saw it, too.

"Other guides would have experiences on tours they were leading, but nothing ever happened on my tours," said Vicki. "People would see things and hear things, but not me. I was too busy working and watching the crowd."

"So one night I decided to shadow one of my colleagues when she was giving a tour, and it was unbelievable! She would walk down the street, and streetlights would go off. I noticed much more phenomena when I went on her tours," said Vicki. "I was enjoying listening to her tell the stories on Burial Hill. One night, all of a sudden she looked as if she was going to fall backwards. She thought it was an owl, and some of the people on the tour felt the breeze. The next day, that guide had an abscessed tooth and she felt as if she had been attacked."

Vicki said that her colleague had not wanted to go up to Burial Hill that night. When she had the experience of nearly falling backward because of something breezing by her, it was the first anniversary of the death of a remarkable young man, poet and artist, Michael "Wolf" Pasakarnis. A gentle man, Wolf predicted his own death by lightning strike on September 8, 2010, at the base of his favorite tree on Burial Hill. According to his friends, relatives and two mediums, he is still with us.

The next year, Vicki was leading a group for Colonial Lantern Tours. She did not want to go up to Burial Hill alone. After all, it was now the second anniversary of Wolf's tragic death, and she was afraid because of her experience the year before. She soldiered on and gave the tour; her EMF (electromagnetic field meter) went all the way from green to red.

"It had happened once before when I was at the memorial to the sailors of the Brigantine *General Arnold*, but on this night, it was at the grave of Thomas Southworth Howland." She continued, "We couldn't figure out the connection as to why the EMF meter spiked, so we went back to the graves to do some quick research to maybe find out why this happened, and it was clear. December 10 was the anniversary of the death of Thomas Southworth Howland's brother, who died at sea. At that moment, a branch came down and smashed to the ground in the cemetery."

The memorial to the crew of the *General Arnold* is one of the most visited monuments in the cemetery. Its inscription reads:

> *In memory of Seventy two Seamen who perished*
> *in Plymouth harbor on the 26, and 27, days of December 1778,*
> *on board the private armed Brig., Gen. Arnold,*
> *of twenty guns, James Magee of Boston, Commander,*
> *sixty of whom are buried on this spot.*
>
> *On the northwesterly side:—*
> *Capt. James Magee died in Roxbury,*
> *February 4, 1801; aged 51 years.*
>
> *On the southwesterly side:—*
> *Oh! Falsely flattering were yon billows smooth*
> *When forth, elated, sailed in evil hour,*
> *That vessel whose disastrous fate, when told,*
> *Fill'd every breast with sorrow and each eye*
> *With piteous tears.*

On the southeasterly side:—
This monument marks the resting place of
Sixty of the seventy two mariners, "who perished
In their strife with the storm," and is erected by Stephen Gale of
Portland, Maine, a stranger to them, as a just memorial
Of their sufferings and death.[26]

The story of the ill-fated sailors of the brigantine *General Arnold* is covered in another chapter, but from the inscription on their marker, it is clear that theirs was a tortuous and painful death.

Their captain, James Magee, was one of the few survivors of the marine disaster. He passed away twenty-three years after the deaths of most of his crew. His grave is near those of his sailors. Vicki and witnesses on one of her tours saw him as a full apparition on Burial Hill. "Captain Magee has touched me on a regular basis on the tour," said Vicki. "A woman on the tour saw a man dressed in uniform walking back and forth between the trees near the sailors' monument."

"Tour guides get brain freeze headaches there. One guide gets so cold near the monument that she will not tell the story of how the crew died at their burial and monument site, but instead she speaks of their fate down on the waterfront," she said. "One couple took a picture of me while I was telling the story and an orb appeared in the picture over my shoulder."

"An orb?" asked this skeptical author.

"I assume that it was James Magee, because he would have visited the graves of his crew up there," replied Vicki. "It was a green face over my shoulder. It felt like someone was right at my shoulder."

Amy Giammasi, who works at the John Carver Inn & Spa, has also witnessed orbs and had them surrounding her when she went on a ghost-hunting expedition with friends. "I am very protected from the paranormal. It's almost like I have a shield around me," she said. "One of my former colleagues at the John Carver Inn was a ghost hunter. We were up at Burial Hill one night, and he took a picture of me and there are orbs around me."

"We went up to the graveyard, and he had had an EMF meter with him. He was also taking pictures of me and two of our friends. The pictures were of green and blue orbs," said Amy.

She continued, "I have been told before by mediums and psychics that there are three angels that protect me, but now I think there are five. That night when we were at Burial Hill, we went up to the Warren family plot. It's in an area with a black wrought-iron fence, almost like a cage. My friend

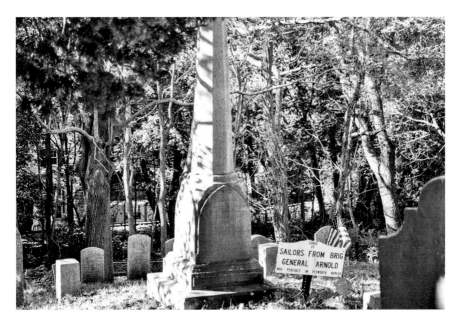

Memorial to the sailors of the brigantine *General Arnold* at their burial site on Burial Hill. *Patrice Hatcher Photography.*

was holding the EMF meter and it would not stop beeping. When I held the EMF meter, it stopped beeping, and the orbs were all around me."

Amy was stunned. She added, "There have been plenty of things that have happened to me, but I have never seen anything like that before."

"Some of our Colonial Lantern Tours of the past incorporated interactive street theater into the tour, with costumed characters who would sometimes jump out to give guests a little thrill," said Vicki. "We decided to go on one of the tours, me and my then eleven-year-old son and a few of the other guides. We had about thirty years' experience between us giving historical walking and ghost tours in Plymouth."

"While we were up on Burial Hill, we are standing near the huge Cushman monument," she continued. "You know the one. It is a twenty-seven-foot obelisk. I turned to two of my colleague guides, and I said I can't tell a story here."

"They gave me a quizzical look," she said.

"I replied to them that even though there are great gravestones and stories, I can't talk here because I get sick to my stomach. And then we all heard a horrible groan—'Raaaahhhh!' It came from an area down the hill close to the First Parish Meetinghouse. We wanted to run, but my eleven-year-old

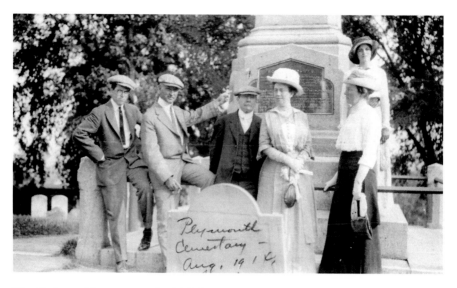

The Cushman Monument on Burial Hill, visited by the Reed and Hanks families in 1914. *Postcard, Reed and Hanks families.*

son wanted to scare it back! We heard it twice. It was like something out of a Scooby Doo movie, but it was real."

"I cannot stand there at the Cushman Monument," she continued. "It makes me physically ill, sick to my stomach, heart racing, and within about three minutes I have to get away from there."

One of the most stunning apparition hauntings at Burial Hill is of a Victorian-era couple who, all research indicates, were real people. They are seen walking to and from the grave of a little girl named Ida Lizzie Spear. They are Elizabeth Russell Raymond Spear and Thomas Spear.

"There is an amazing photograph that some local ghost hunters took of a man and a woman in Victorian style dress. They are seen walking down the pathway from Burial Hill, but they are not really there. The pathway is to the left of the John Carver Inn, at the west side of the hotel and leads from Burial Hill to Summer Street," Vicki explained.

At that moment, Amy Giammasi, who was working at the John Carver Inn's Hearth 'n Kettle Restaurant that evening, overheard myself and Vicki discussing the apparition of the Victorian couple.

Amy came over and politely asked to interrupt our conversation. She said, "I saw it, too, in 2010. And, I don't mean the photograph. I saw the man and the lady. I saw them with my own eyes."

Vicki and Amy had never met before.

Amy described the apparitions. "It looks like a man in a suit, a tall, thin man, and a lady in a long dress. I was standing by a tree up on top of Burial Hill, not far from the pathway that leads down past the hotel and to the street. I saw my friend clear as day. But then I saw the man and the lady. They were holding hands walking down the hill, but they did not have feet. The man wore a stovepipe hat, the woman was wearing a cloak with lace and she had on a long dress. It scared my friend so bad that he yelled, 'We need to get outta here!'"

"I knew they were not going to hurt us," continued Amy. "So, I told him that. I said, 'Look, they are just walking.'"

He replied, "But, they don't have legs!"

"When they got close to us, they just disappeared," she said. "I do have to admit that when I first saw the couple walking, they were glowing, but I still thought they were real. My friend doesn't know this, but the closer they got, I got nervous. I realized they were not real because they had no legs. When they got really close they disappeared, they just vanished."

"I asked the person who took the photo to take me to the place where he shot it," said Vicki. "I wanted to see where the picture was taken to try to debunk it. A lot of times when you look at the headstones on Burial Hill they look a lot like a person's silhouette."

"So I wanted to see where he took this picture because it is so easy to trick the mind," she continued. "He stood exactly where he was standing when he took the shot and there were no large headstones in the area that would create something that could be mistaken as a person or a ghost. But then I saw a little stone, a tiny, tiny white headstone near a big bush. Together, we dug a bit and pulled away the brush and the grass so we could read it. We looked closer at the stone. It read 'Ida Lizzie, 3 years.'"

"While we were clearing away the brush from the stone, I heard a very loud breath on the hill behind me, like a 'Haaah!'" Vicki reported. "We both heard it. We ran up the hill to see if anyone was around. I looked around for a possible tour, a ghost tour or something because lots of tours come up to Burial Hill at all times of the day, but no one else was around. A couple of our guides won't walk through that low area. We call it the hollow."

Research done by me confirms that, indeed, there is a small white stone with the inscription "Ida Lizzie, 3 years" on it in that exact area. [27] It marks the grave of Ida Elizabeth Spear. She was born on September 19, 1856, to Thomas Spear and Elizabeth Russell Raymond Spear in Plymouth. She died on January 23, 1860. She was the sister of Thomas Irving Spear, George R. Spear and, interestingly, another Ida Lizzie Spear, whose genealogical

Roots of the tree with "hands" on Burial Hill, said to be the location of a Native American spirit that watches over the cemetery. *Patrice Hatcher Photography*.

records indicate that she was born five years after Ida Elizabeth's death. The baby Ida Lizzie was born on June 1, 1865, in Plymouth and died just two and a half months later, on August 20, 1865, in Plymouth.[28]

"I think the Victorian couple we see are her parents," said Vicki. "I think their haunting is a residual haunting of their visits to her grave."

I think she is right.

When asked her opinion of whether Burial Hill is haunted or not, psychic Patrice Hatcher replied, "There is energy and activity at the Summer Street entrance to Burial Hill. It is not of the Pilgrims and the seventeenth century, but it is of the Victorian era and the nineteenth century."

One last story about Burial Hill. Legend has it that there is a spot on Burial Hill on top of the staircase by a huge tree. The tree has a peculiar feature. It has roots that look like hands—hands that extend down from the tree into the ground and up from the ground out toward the tree. Some say a Native American guardian spirit sits and watches over people at that tree. If a visitor to Burial Hill does anything unacceptable or inappropriate, the guardian spirit will let them know in terrifying fashion.

When asked about that legend, Vicki replied, "The EMF meters go off every time at that tree."

4

CHECKING IN BUT NOT OUT
AT THE JOHN CARVER INN & SPA

The spirit of 1776 is alive and well at the John Carver Inn & Spa, located on Summer Street in Plymouth. Its façade and decor are authentically early American reproduction Federal style, with a red-brick exterior and broad columns supporting a soaring portico. It resembles a scaled-down version of a building designed by Boston's renowned architect Charles Bulfinch, who was largely responsible for defining the American Federal style of architecture in the early 1800s. His projects are well known. He designed the Massachusetts State House, Boston's Faneuil Hall expansion, both Harrison Gray Otis Houses, the Old Connecticut State House and the United States Capitol Building in Washington following Benjamin Henry Latrobe.[29]

Guests are welcomed into a well-appointed lobby reminiscent of a parlor in a late eighteenth- and early nineteenth-century mansion. The atmosphere at the John Carver Inn harkens back to the time of the Sons of Liberty of the American Revolution and our country's other forefathers, including Washington, Adams, Jefferson, Franklin, Hancock, Monroe and Hamilton.

Perched on a hill, the John Carver Inn & Spa overlooks Plymouth's Town Brook to its south, Market Street and Main Street Extension to its immediate east, Town Square to its immediate north and Burial Hill to its immediate north and west. It is centrally located in town, at the intersection of many thoroughfares—Market Street, Main Street Extension, Sandwich Street and Summer Street. It is also built very near the geographical center of what would have been the Pilgrims' first settlement.

Vintage postcard of the John Carver Inn, overlooking Summer Street and Town Brook, 1970s. *Plastichrome by Colourpicture, Boston.*

In addition to being one of the major hotels in town, the John Carver Inn & Spa is host to events and activities, chief among them Plymouth's noontime Rotary Club lunch meetings, weddings and a popular interactive dinner theater that offers a variety of entertainment, including mystery, comedy and musical performance packages. It is also where I conducted many of the interviews for this book.

The inn is an ideal place to pop in, visit or spend a weekend—or a week. Hearty food can be had in the Hearth 'n Kettle Restaurant, martinis can be sipped in a swanky bar named WaterFire Tavern and a day of pampering and luxury can be had at the first-class Beach Plum Spa. The Pilgrim Cove Indoor Theme Pool offers something for the kids—an eighty-foot waterslide winding its way through a life-sized replica of the *Mayflower*—and something for the grownups: a whirlpool Jacuzzi built into a replica Plymouth Rock.

While the John Carver Inn & Spa's architecture, furnishings and atmosphere reminds us of American life in an earlier time, much of the area where it stands has changed drastically. A six-year, thirty-acre urban renewal project costing $2 million beginning in 1964 dramatically changed Plymouth's landscape and the look and lay of the neighborhoods on the southern and western boundaries of Town Square.

The late Dr. Karin Goldstein, historian and curator at Plimoth Plantation, wrote about it in her Boston University doctoral dissertation, "From Pilgrims to Poverty: Biography of an Urban Renewal Neighborhood," which was later adapted as a chapter in the book *Beyond Plymouth Rock: Volume II, A Welcoming Place*:

> *In January 1964 a wrecking ball struck a house on the south side of Town Brook west of Market Street, shattering the calm of a cold morning. As members of the Plymouth Redevelopment Authority looked on, the widespread demolition of buildings in the Summer–High Street neighborhood began. When the massive redevelopment project was completed six years later, more than 100 buildings in a 30-acre downtown neighborhood had been demolished, bringing about the most dramatic change to Plymouth's townscape in its more than 300-year history.*[30]

Urban renewal has its roots in the Depression era. Shantytowns— substandard and unsanitary housing—led to illness and a general unseemly appearance of its structures and the people forced to live in them. Blight brought down nearby property values and made economic growth almost impossible.

After World War II, the U.S. government made it easy for municipalities to take advantage of federal funds to subsidize housing and economic development projects that would eliminate blight and open up opportunities to redevelop areas that had fallen into poverty and disrepair. Simply put, through redevelopment, cities and towns could create new, affordable housing with modern amenities and draw new businesses to the area, increase industry and thereby develop a sound economic structure for better living, commerce and business.

Goldstein wrote:

> *By the early 1950s, "slum clearance" had become "urban renewal." The 1954 federal housing act broadened urban renewal by encouraging business development through plans known as Workable Programs. A Workable Program had to contain a master plan with an administrative body and sufficient funding, code enforcement, an inventory of blight, evidence of "citizen participation" and a commitment to re-house residents displaced by redevelopment. Because the act encouraged private investment, public housing became one of many urban renewal tools, which could now include commercial and institutional projects. Both the 1949 [Title 1 of the*

Federal Housing Act] and 1954 acts had major consequences for Plymouth's Summer-High street neighborhood just west of Town Square. Instead of limiting redevelopment of a blighted residential area to low-income housing, the two federal acts encouraged "best use." As a result, a redevelopment project could provide more property tax revenue by replacing low-income apartments with a mixture of commercial development and middle-income rental housing.[31]

By the 1960s and into the early '70s, Plymouth was the place to go if you wanted a new apartment, a new house and a job. It was the beginning of a population boom brought about by the economic development of an industrial park, the building of the Entergy Pilgrim Station Nuclear Power Plant, the availability of large tracts of inexpensive land being developed into middle-class suburban housing developments and a very low tax rate for citizens because of the decisions of the town government. According to the United States Census Bureau, between 1960 and 2010, Plymouth's population grew from 14,445 to 56,458, a whopping, cumulative 171 percent!

But it did take the town a decade or so to get to the point where redevelopment was a reality. The Plymouth Redevelopment Authority was established to oversee the project.

Goldstein's research confirms that fact:

The 1949 Plymouth Compact suggested new uses for the Summer-High street neighborhood, an area with outdated, overcrowded dwellings and limited commercial use. It was a prime target for redevelopment. Plymouth had little chance of attracting new industry, the study committee concluded, and recommended that the town focus on developing tourism. Having a blighted neighborhood just 200 feet from historic Town Square was an embarrassment. Long ignored and isolated from modernization, the area did not fit contemporary needs: serving an increasing number of tourists, providing space for more automobiles and upgrading dwellings to meet the postwar ideal of an American home. Consultants recommended that the densely-built neighborhood be cleared and redeveloped. By 1957 the town voted to acquire properties in the Summer-High street area and demolish dilapidated buildings. Even without a comprehensive plan, the town demolished 18 buildings on the first block of Summer and High streets. Early plans were to use the cleared land for parking. Unfortunately, the land proved too hilly and was deemed not close enough to the downtown business district. The cleared land lay fallow for many years. Because these

early purchases were not part of an official renewal project, they were not properly documented. Sadly, many of these buildings on the north side of Summer Street had been built between 1690 and 1725 and were among the town's oldest structures.[32]

The demolished houses were an important part of the fabric of the Summer-High Street neighborhood, and their loss is evident when one takes a critical look at Plymouth's housing stock. One finds very few representations of that part period of the town's history.

Good examples include the row of houses located directly across the street from the John Carver Inn & Spa on Summer Street. That block of homes includes Plymouth's oldest standing house, the Richard Sparrow House (1640). The Sparrow House is now one of Plymouth's most delightful gift shops, the Sparrow House Pottery and Gift Shop. Its exclusive and limited-edition pottery, handmade jewelry, elegant accessories and personal service and attention by its staff make it the preferred choice for shopping for gifts of the highest quality. There are other well-preserved examples of Federal period homes along that stretch of street from the early to mid-nineteenth century, as well. One of them is the Harlow-Bishop House, which was removed from its original location to across the street.

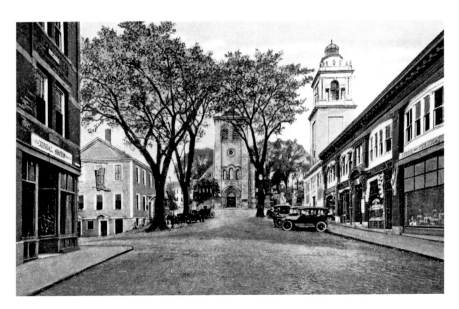

Vintage postcard of Town Square, early 1900s. *C.T. American Art.*

When High Street is spoken of today, many newcomers to town give a quizzical look and scratch their heads. Why? Because High Street was virtually eliminated by the Summer-High Street urban renewal project of 1964–70. Only one house remains on High Street: the Ryder Home.

Ironically, according to an article Dr. Goldstein wrote for the *Plymouth Patch* online newspaper in 2012, the Ryder home, built around 1809, was itself erected on a street that changed its name. She wrote:

> *High Street dates back to circa 1800, when two of Plymouth's leading citizens, Dr. James Thacher and Judge Joshua Thomas, experimented with land speculation. The New England economy was growing in the early years of the 19th century from a combination of industry and coastal shipping. As the population increased, more houses were built. The two men took a gamble that the good economy would pay off—they bought hilly land between Summer Street and Burial Hill, and laid out house lots along two connecting lanes. In the past, streets generally followed plot outlines. In this case, the two men laid out roads through the middle of their properties to create two rows of house lots. Thomas Street ran from Russell Street to Spring Street, and Thacher Street continued east to Market Street. In his introduction to Thacher's History of Plymouth, the doctor may have had an ulterior motive for purchasing land adjacent to the cemetery—after all, Thacher did teach medical students about anatomy! No one knows if Dr. Thacher was ever involved in resurrectionism, but it makes a good story for the ghost tours that frequent downtown Plymouth every night.*[33]

Reader, take note. Dr. Thacher purchased land directly contiguous to Burial Hill, but we will get to that story later.

Goldstein added, "The two streets were officially combined and renamed High Street in 1823."[34]

But what is so stunningly evident when one traverses the area where the Ryder Home is located is the juxtaposition of an original home built on its plot in Plymouth next to the modern, sprawling 1960s apartment complex of Spring Hill (although the latter's architects and builders did attempt to adhere to some historical influence by incorporating a "Williamsburg-style" façade in the multi-storied structures). And this street was completely abolished, and removed from the map, save for the Ryder Home.

By the mid-nineteenth century, the Ryder Home on High Street had been turned into a home for older people and was operated by the Plymouth Fragment Society as a residence for older women. The Town of Plymouth

recently purchased the well-maintained property, restored it and added new amenities to the apartments. It remains a beloved and cherished private home for women.

Outside the Summer Street and Ryder House area, one has to travel beyond the redevelopment boundaries south on Sandwich Street to the Plymouth Antiquarian Society's 1677 Harlow Old Fort House and to the Pilgrim John Howland Society's 1667 Jabez Howland House to see residences from the seventeenth century.

A total of 105 buildings, houses mostly, were demolished. According to Goldstein:

> *The last parts of the 1962 urban renewal plan were completed by 1970, less than 10 years after the project was approved. When the dust settled, residents were left with a very different townscape than the one they had known. While much of the south side of Summer Street and Willard Place remained the same, the north side of Summer from Market Street to beyond Edes Street was unrecognizable. High Street was no longer, and Church and Spring streets had been converted to pedestrian walkways. The south side of Sandwich Street was cleared of buildings, improving the view of the Town Brook, and most of the north side was occupied by a Friendly's restaurant* [now a Dunkin' Donuts].[35]

Let's get back to the John Carver Inn & Spa, the site of hauntings reported by front desk staff, wait staff, hotel guests and visitors. Why the hauntings?

According to the former purveyors of Colonial Lantern Tours, legend has it that the inn was built on the site of a late eighteenth- or early nineteenth-century house for medical students, next door to the cemetery at Burial Hill. The reader can guess what happens next. Allegedly, the students took to grave robbing to practice anatomy and experiment on the cadavers. Where did the students take the bodies for their medical experiments? Allegedly, to a house located on the site of the John Carver Inn. Do we know this for a fact? No, but remember the story of Dr. Thacher of Thacher Street (later High Street and now not a street at all), written by Dr. Karin Goldstein in her *Plymouth Patch* article? Did he have medical students procure human remains for "educational purposes?" Could that be the reason for the hauntings? Or is it just the basis for the legend?

Along with the Spring Hill Garden Apartments, the John Carver Inn was an essential element in Plymouth's Urban Renewal Project. Tourism, a major economic generator in the region, compelled the Plymouth Redevelopment

Authority to call for a large, modern hotel with all sorts of family-friendly amenities to be built within the Summer-High Street project.

Goldstein wrote, "The first block of Summer and High streets had been designated for a tourist hotel. The town needed a large hotel for visitors, and the location was convenient to Plymouth Rock and the historic area. The original bidder…had proposed opening a Holiday Inn."[36]

Bad luck dealt a bad hand to the original Holiday Inn and its owners; it went bankrupt and closed in 1970. Shortly after, a new hotelier purchased the property and reopened it as the John Carver Inn (the spa came later).

"It's not the hotel itself to me that makes me feel uneasy. I think it is a lovely place, very pleasant, but it is the underlying undercurrent of the entire Town Square area that just doesn't feel like a happy place," remarked psychic Patrice Hatcher during one of her meetings with me.

She continued, "Think about all the death and sacrifice in this area of Plymouth, and the sadness and depression, the lack of hope that the Pilgrims and the Native Americans alike felt here in this very spot. It feels like a genetic memory to me."

When asked about the hotel's location adjacent to Burial Hill and the effect a graveyard would have on that genetic geographical memory, Patrice replied, "I don't believe that any spirit is left in bones and body after someone dies. Spirits are energy, so they are more about representing who they were when they are alive. When people see them, hear them, feel them, or smell them, the spirit is doing what they would be doing in life."

"But it is the history of this land, and the story of this land," she continued. "The plague that decimated the Native American Patuxet tribe and how they became an annihilated race, the Pilgrims' need for survival and their nearly insurmountable struggle, all the energy needed for survival, it feels like negative energy to me."

What are the stories of the hauntings at the John Carver Inn & Spa—in particular the stories told by guests and staff—that involve unexplainable experiences that leave them shaken and afraid, with some guests vowing to never return to the hotel?

Amy Giammasi has worked as one of the wait staff at the John Carver Inn & Spa for decades. Diners at the Hearth 'n Kettle know her by name and enjoy her engaging personality and warm hospitality. Amy described one particularly memorable Christmas morning when she and one of the front desk staff were in the hotel's kitchen.

"We were making breakfast for ourselves, which is our usual routine when we have to work a long day on a day like Christmas," she said. "It was

Christmas Day 2013 at about 7:00 a.m. My coworker was making eggs, just flipping an egg in the pan, when all of a sudden she heard a jiggling sound, and the pan went flying across the kitchen. At that point, I had just walked into the kitchen, and another pan that was just sitting on the stove went flying across the kitchen," she said. "I yelled, 'You need to knock it off!'"

"We all know this place is haunted," she added.

Some say that the third floor of the hotel is where most of the paranormal activity is concentrated. I asked Amy if she had ever heard anything about paranormal activities on the third floor. Perhaps guests, housekeepers, maintenance workers or room service staff had seen, heard or felt something and reported it.

She replied, "Absolutely! Guests have described a room on the third floor, it is somewhere in the 320s. They have reported that the room makes them feel very nervous. One guest in particular told the front desk about her experience when she was checking out."

"She and her friend were staying in adjoining rooms on the third floor," Amy continued. "She said she felt uneasy because when she was in bed trying to fall asleep she felt a presence, a pressure on her as if someone was hugging her from behind. It made her so uncomfortable that she got out of bed and was almost to the door that connected her to her friend's room, and at that moment, the television set turned on."

"She was extremely rattled, but she shut the television off and darted over to the connecting door to her friend's room," said Amy. "She and her friend opened the adjoining room doors at the exact same time. Of course, they screamed! Who wouldn't?"

"But, what is really scary is that both of them in two different rooms had the same experience, that something, someone, was hugging them from behind while they were sleeping or trying to fall asleep," said Amy.

Vicki Noel Harrington, owner of Plymouth's Spirit of Plymouth Walking Tours, described a similar experience that happened when she and her extended family stayed at the hotel for Thanksgiving.

"One Thanksgiving, my mother-in-law treated our family to a 'staycation' holiday. We had the classic, authentic dinner at Plimoth Plantation." (Take note: Everyone should have Thanksgiving dinner at Plimoth Plantation at least once in their life.)

"After dinner and a visit to the Pilgrim Village and the Wampanoag Settlement, we came back to the John Carver Inn for the night," she continued. "My brother-in-law and sister-in-law were sleeping in another room with their children, and my husband and I were in our room with three young boys."

"I have to admit I slept like the dead that night so as far as I know, nothing happened in our room. But the next morning at breakfast, my brother-in-law and sister-in-law told us one hair-raising story!" said Vicki. "From what they said, the television repeatedly turned itself on all night long. They thought that their eight-year-old son was doing it, and asked him over and over to stop. When they looked where he was and where the television remote control was, it was nowhere near their son."

"We get all sorts of reports about televisions going on and off by themselves, and reports that water spigots in the bathrooms turn on and off by themselves, and that the lights turn on and off by themselves!" exclaimed Amy.

"While giving a tour for Colonial Lantern Tours, a guest took a picture of me," added Vicki. "When she showed it to me, the picture had me in the middle, a demon over my shoulder. We were in the John Carver Inn parking lot."

Robin Ruehrwein is a self-described "work-at-home mom, stepmom, trophy wife, blogger…loving life in New England" and a social media influencer whose lifestyle blogs feature articles on "life as a mother, travel, fitness, crafts and recipes." She is a popular contributor to social media sites, offering tips about fun family activities. She has been featured on CBS Boston and New England Cable News, among other media outlets.

Robin has visited the John Carver Inn & Spa. She and her husband spent a night there in 2013. She described their experience in her blog, *Masshole Mommy*, in an entry entitled "Our Night in a Haunted Hotel." (Sections reprinted with permission of Robin Ruehrwein):

> [Robin said that she and her husband] *decided to go on a pub tour led by Colonial Lantern Tours. It was called "The Naughty Pilgrims" and promised "amazing tales of early colonists and their misdeeds. Stop at some unique pubs to learn about the legends they hold. Discover why the John Carver Inn is believed to be haunted. Learn about witchcraft and superstitions in the 17th century."*
>
> *If you have been around here* [reading my blog] *long, you know that I love, LOVE haunted ghost tours and have dragged my poor, unsuspecting husband along on dozens of them. So, I emailed him back and told him to reserve our spots because well, who wouldn't want to hear all about some pilgrim shenanigans.*

The John Carver Inn was a feature on the tour, so the couple decided to book a room and make a night of it.

They put us in room 311. Guess what the most haunted room in the hotel is? 309. So, we're up on the 3rd floor of the hotel, all of which is supposed to be haunted, but we end up right next to the room with the most activity. I knew I wasn't going to get any sleep that night....

By around 10 PM, we had to get back to the hotel so that we could get some sleep. But before we went to our room, we took a picture of the infamous room 309, which oddly enough was vacant that night. There were people staying in room 307 on the other side, and of course we were in 311, but they didn't put anyone in the haunted room that night.

As soon as we got inside the room, the hairs on the back of my neck stood up. I'm sure it's just because I scared myself into thinking that monsters were going to get us in the middle of the night. Stories of other people's experiences in the hotel include things floating, lights turning on and off spontaneously, the TV turning itself on and off in the middle of the night and slight "breezes" inside the rooms. I informed [my husband] that we would be sleeping with the lights on.

Stupidly, I got this ghost meter app on my iPhone and even more stupidly, I thought it would be fun to use it inside the room. I had goosebumps, I swore I felt someone breathing on the back of my neck and my app was going nuts. I kid you not, we weren't back in the room for ten minutes when I told Chris that I had to get the hell out of there.

Mind you, I was actually part of a paranormal investigation team at one point and I've actually been in real haunted houses and this place scared me more than any of the actual haunted houses that I've been inside.

We went to the front desk and asked to change rooms. We told them that we had just been on the ghost tour and they told us that the third floor was haunted and that we weren't comfortable staying up there. They laughed at us, but gave us a room on the second floor. I still didn't get any sleep and I swear I heard at least six or seven random knocks and noises from inside our room.

But we survived. And I swear to god that I'll never stay at The John Carver Inn ever again.

More of Robin's story about her night at the John Carver Inn can be found at her blog.[37]

Unfortunately, the owners of Colonial Lantern Tours, former educators Dan and Diane Finn, have retired. Their tours of Plymouth history, legend and lore are missed by the entire Plymouth community.

While interviewing Patrice Hatcher at the John Carver Inn & Spa, I asked her opinion on the types of activity reported there. She replied, "A

lot of this can be explained. There are reasonable explanations for most of this activity. For example, televisions going on and off can be explained. Most hotel walls are not made of concrete or lead, so when someone in the next room presses a button on their remote control to change a channel or turn on the television in the room they are in, the electronic waves or current from the remote control could go through the wall into the next room. Doesn't that seem logical and easy to explain?" she asked.

I agreed, but what of other reported activities of objects being thrown across a room and people being touched by a spirit?

Patrice said, "Energy levels of a spirit would have to be very, very strong to move an object like a pan being thrown across a room. Some people might think that it is an angry spirit, or one who may have had a traumatic death, but I haven't heard about any accidents here in this building [John Carver Inn & Spa] that could be related to a haunting like that."

"Something else to remember," she added, "is that this is a hotel where a lot of people, different types of people, stay and leave, go in and out. Thousands and thousands of people have stayed here over the past fifty years or so. It would not surprise me that some guests of the hotel may have brought their own 'baggage,' so to speak, with them."

It seems likely that the energy of the land is to blame for the uneasiness and paranormal activity at the John Carver Inn & Spa. The geographical genetic history of five hundred years—from the suffering of the plague that caused the deaths of thousands of Native Americans at their Patuxet settlement to the forcible removal of residents and residences in the 1960s—is a negative history. Does the land remember? Are memories ingrained in a place? Is it the land beneath the site of the hotel that can't let go of Plymouth's dark days of plague, suffering, fear, uncertainty, violence, disruption and displacement?

Perhaps it's those spirits and their energy that never check out.

5

THE HOUSES OF THE DOWNTOWN

B uilt in 1725, the Captain Thompson Phillips House is one of Plymouth's oldest standing houses. It is also home to one of Plymouth's oldest earliest known and documented hauntings. Thompson Phillips built his stately home on Middle Street, where it stands today. Who was responsible for the "pale blewish light" and the groans emanating from the house's walls?

Historian Patrick Browne recounts the tale in an October 5, 2014 entry on his blog, *Historical Digression*:

> *On October 1, 1733, Ann Palmer left the Captain Thompson Phillips House on King Street (now Middle Street) in Plymouth, Massachusetts under distressing circumstances. A spinster, she had rented rooms and resided there for about a year with several other tenants. The others had already moved out, allegedly due to the fact that the house was haunted. She was the last of them to go, leaving empty and forlorn what had been, up until a few years prior, the most elegant house on the street. Later that night, Jane Crandon, who lived just around the corner in plain sight of the Phillips House, spotted a strange light coming from what had been one of Ann Palmer's rooms. Crandon ran to the house to determine herself whether there was anyone inside but soon realized the house was empty and the light was gone.*[38]

The Captain Phillips House is now a five-unit apartment building. According to Vicki Noel Harrington, owner of Spirit of Plymouth Walking Tours, it is the only house in Massachusetts that is listed as officially haunted.

Hannah Phillips, Captain Phillips's young daughter, inherited the house from him after he met his end in a watery grave, having been swept off the deck of his ship in 1729. As a minor, Hannah was not able to manage the property herself, so her grandfather Josiah Cotton took over responsibilities. He rented the house to tenants, including one John Clark, a joiner who had his shop in part of the house. In 1733, there was a dispute between Cotton and Clark, most likely about the money Clark owed Cotton for rent and because Cotton wanted to add a tenant to the property, which would force Clark to relinquish a room he was using.

Clark promptly moved out. "The remaining tenants—including families of Clark's business associates Thomas Savery and Samuel Holmes, several apprentices, and [the] spinster named Ann Palmer—all followed suit. At the time of the argument at Isaac Lothrop's house, the Phillips mansion had been vacant for nearly two months."[39]

"Essentially, everyone broke the lease and moved out, saying that Captain Thompson Phillips had returned from his watery grave and brought the devil himself with him," said Vicki. "Doors were opening and then were slammed and shut. Windows opening and closing. That was the sort of stuff that was reported as the haunting."

"Ultimately, Josiah Cotton took them all to court," she added.

"In February 1734, Josiah Cotton and John Cushing Jr. (the executor of the Phillips estate) brought action against Clark and Savery alleging that they had 'done us damage by telling stories there was no just reason for.' They wanted £200 for their losses. It was during this sensational trial that the above quotes came out describing what had been going on in the house—testimony from residents and neighbors alike."[40]

What were those stories that Cotton referred to?

As several Plymouth residents would later testify in court, the joiner [Clark] frequently had asserted that the dwelling was haunted by the specter of Thompson Phillips and other "evil spirits." Isaac Robinson, for example recalled an incident in which Clark spied a preternatural light—"plain as the light of a Candle"—in the "front alley's upper window." In a conversation with minister Nathaniel Leonard, Clark described "a great noise like the banging of a door too & fro," which he maintained, confirmed his suspicion "that there was Something Extraordinary" going on in the house. Timothy Holloway, too, related a similar encounter in which Clark told him "that he could not live no longer in Mr. Phillips house." When asked to explain, Clark allegedly

asserted that "because of such unusuall noise in the house…he nor no body alse could live in it because it was haunted with evill spirits."[41]

Browne added in his blog: "Inexplicable groans that sounded like someone in a 'dying posture.' The sound of canes rapping against the walls. Doors, cabinets and drawers would fly open. One night, a neighbor, Mary Little, spied a 'pale blewish light' in the garret window and feared it was a fire. She watched it for about a half an hour until it disappeared….As [Douglas L. Winiarski wrote in his article "'Pale Blewish Lights' and a Dead Man's Groan: Tales of the Supernatural from Eighteenth-Century Plymouth" for the *William and Mary Quarterly*], What began as a slander suit focusing on the intentions of the defendants thus quickly devolved into a trial over the reasonableness of wonder lore itself."[42]

People in 1730s colonial America found themselves at an intersection of cultures. Past folkloric beliefs about the paranormal were being challenged by the philosophical, intellectual viewpoints of the Enlightenment. Cotton himself rallied against the rumors and allusion of spectral forces by taking the former tenants to court for defamation. But the Superior Court of Judicature, Suffolk Court ruled against Cotton twice, once in the original trial and then in his appeal. The tenants were found not guilty of defamation.

Douglas Winiarski wrote of Josiah Cotton:

Arguably Plymouth's most prominent citizen, Cotton had every reason to expect that his opinions would carry weight in the community. He firmly believed that a court victory would curb the rabid superstitions of his neighbors and restore reason to a town beset by supernatural speculation. To further this end, therefore, he began work on an essay decrying the dangers of popular wonder literature, the legal excesses of the notorious Salem witch-hunt, and the widespread "Damage…done to Mens Estates & Names & Lives" by the erroneous beliefs of ordinary folk. Drafted in 1733 at the height of his protracted conflict with his tenants, the essay, entitled "Some Observations Concerning Witches, Spirits & Apparitions" was never completed. Nevertheless, it was a crucial component in what fast became a sweeping campaign to discipline the loose-tongued slanderers of the Phillips mansion. Thus, although the drama of the Plymouth "witch cause" unfolded in a secular courthouse, Cotton's private writings reveal how, in the plaintiff's mind, purging society of superstition had become a sacred rather than a civil cause.[43]

Ghostly figure in upper-right window of house on North Street. *Patrice Hatcher Photography*.

The resulting judgement by the court took the Phillips House case a step further in the social and cultural mindset of 1730s Plymouth, which extends into the twenty-first century. It is the notion that it is not a crime to believe in ghosts, and that one cannot prove that there is no such thing as ghosts.

Browne added in his blog: "Unable to sell or rent the Capt. Phillips House, Cotton decided to move into it with his family on March 29, 1734. The Cottons never saw or heard any ghosts. It took some time, but the excitement and rumors eventually dissipated. In November 1739, Cotton managed to rent the house and he moved back to his North Plymouth farm."[44]

So, is the Captain Thompson Phillips mansion haunted? If recent events are any indication, yes.

"I talked to a woman who lived in one of the upstairs apartments," said Vicki. "She said that her door would open and shut on its own."

Psychic Patrice Hatcher added to the intrigue of the Phillips House when she told of a ghostly figure she saw in one of the upstairs windows of the house next door. "I was playing tourist in Plymouth, one of my favorite things to do. I was on a walking ghost tour, and we had just finished up learning about the Captain Phillips House. I looked at the house right next door and saw a person in the window! It was so visible, so I took a picture of it. If the Phillips House is not haunted, then the one next door is most certainly haunted."

Plymouth's North Street, located at Shirley Square where Court and Main Streets meet, is one of the town's most haunted streets. "Every single building on that street has a story," commented Vicki.

Chapter 2 of this book, "Plymoutheans," describes Patrice's experiences when she had her shop, Ishtar's Avalon, on North Street. In the same chapter, the hauntings of the Spooner House (27 North Street) are discussed at great length by Vicki. If those stories haven't convinced the reader that North

Street is haunted, allow me to provide further evidence of spectral beings and spooky situations that cannot be explained.

Vicki described an experience she had on a guided tour led by a competitor. Curious to get a different perspective, she attended the tour that evening.

"The story goes that if you knock on the door of a particular Federal-style house on North Street, someone or something knocks back." She continued, "My son was on the tour with me, and he was brave enough to take a chance, so he knocked on the door. Nothing happened." Vicki added, "But I took a picture, and in that picture is an image of a little girl and an image of a man in a tri-cornered hat. If you look hard, you can also see the eyes of a cat in the picture. Now, the cat can be debunked, but not the little girl and not the man in the tricorn hat."

"There is an apartment on the second story of that house," Vicki continued. "I met someone who lived on the second floor, and he didn't stay there very long. He said there was a man on the stairs who would follow him to the shower, and he didn't like it very much."

Who would?

The Winslow-Warren House, located at 65 Main Street at the corner of North Street in Shirley Square, was home to a family of great importance in the thirteen colonies' fight for freedom from Great Britain. Now home to four businesses, the house's history is published on the current owner's website:

> *In 1757 James Warren and his wife, Mercy Otis (sister of the famous Colonial Jurist, James Otis of Barnstable) moved into the house. The Warrens were among the leading Patriots of the Revolutionary era. While residing at the house, James Warren was elected from Plymouth as a member of the House of Representatives. According to Mercy Otis Warren's "History of the Rise and Progress and Termination of the American Revolution" (Boston, 1805), which was written in the North Street house, James Warren (an attorney) and patriot Samuel Adams hatched the idea of the Revolutionary Committee of Correspondence to inform other colonies of colonial reactions to British violations of the Constitutional Rights of American Colonists. It is more than likely that these important American Revolutionary History discussions took place in the Winslow-Warren House. Author Nancy Rubin Stuart asserts that James and Mercy often hosted meetings with John and Samuel Adams and other Sons of Liberty at their fireside in the house during the tumultuous years leading to the American Revolution.*

In 1773, in this house, Mrs. Otis Warren wrote the satiric drama, "The Adulator." One year later James Warren, still a resident of the North Street house, was elected a member of the First Provincial Congress of Massachusetts. On June 19, 1775, after the battles of Lexington and Concord, he was elected President of the Provincial Congress. In March of 1790, while a resident in the house, Mercy Otis Warren wrote and published her much acclaimed book of "Poems Dramatic and Miscellaneous." It was also from this house that she carried on her famous correspondence with President John Adams and Abigail Adams, Samuel Adams, John Dickinson, James Otis, Generals Henry Knox and Benjamin Lincoln, among many other luminaries of the Revolutionary era. James Warren and Mercy Otis Warren's portraits were painted by the preeminent American portrait artist of the time, John Singleton Copley. They hang today in the Museum of Fine Arts in Boston.[45]

The Winslow-Warren House was built in 1726 by British general John Winslow (1703–1774), the great-grandson of Pilgrim Edward Winslow. His portrait hangs in Pilgrim Hall Museum. It is General Winslow who many believe haunts the Winslow-Warren house today.

"There is a reported haunting of a woman in the house as well," said Patrice. "Someone heard coughing in the house when no one else was there. If the house is haunted by a woman who was coughing, it could be the woman Mercy Otis Warren wrote about in her letters. She was house guest of Mercy's and she died of influenza while staying with her. Could she also be haunting the Winslow-Warren House along with General Winslow? Maybe."

When Patrice moved her shop, Ishtar's Avalon, from North Street to the Winslow-Warren House in the first decade of the twenty-first century, she had a significant amount of construction work done in the space. That work was being performed on a strict deadline in preparation for the grand opening. Members of the Twelve Tribes, an international religious sect that has a community home and businesses in Plymouth—one of them a construction and woodworking business—were hired by Patrice to build the space for reading rooms and displays for the new shop. (Male members of the Twelve Tribes wear their long hair tied back and keep full beards, as their religion dictates.)

Patrice described a hair-raising and surprising incident at the shop one evening just prior to opening. "We had a deadline to open, and the members of the Twelve Tribes were in the building doing work. They were cutting

lumber; they took a break when their wives came in to feed them dinner; the wives cleaned up dinner and left, and then the men left," she said.

"The men had to make a run to the local building supply store for more materials, and I was alone in the shop in the Winslow-Warren House. It was just prior to 10:00 p.m.," said Patrice. "I was in the front area of the shop putting together a piece of furniture. I turned around, and there was a man sitting on a pile of wood."

Patrice describes the man as having a big beard and hair pulled back away from his face.

"I said to the man, 'Oh, I thought everyone was gone to get more wood.' And then he was gone!" She continued, "I said to myself, 'Who is this person? I need to know. I just have to know who he is.'"

Patrice suspected that she knew who this man was, but it was not someone she had ever met in the present day, despite his resemblance to members of the Twelve Tribes who had been in the building just minutes before. She did her research and discovered what she instinctively already knew. This man was General John Winslow.

The Winslow-Warren House at the corner of Main and North Streets. *Patrice Hatcher Photography.*

"I found a picture of him. He was the one who built the house before Mercy Otis Warren and her husband moved in." She continued, "I believe he was there to oversee the construction and everything else that was going on at the building."

Later in his life, General Winslow moved to Marshfield and Duxbury.

"I saw this man clear as day. I was looking at a full person. He was not ghosted out, nor did he appear as a flash like ghosts sometimes do." She added, "He was not threatening at all. He was just sitting there looking at me, sitting on the pile of wood with his leg up, looking around and assessing everything. It looked like he was there to work."

The Winslow-Warren House has had many different iterations in its nearly three-hundred-year history. Remodeling, breaking up the interior into separate office suites, changing the façade of the building and overall modernization have changed its look, but not its essence. Clearly, the original occupant knew exactly where he was—right at home in the house that bears his name.

Leyden Street is considered one of the oldest streets in America. Historian James Baker describes it in his book *A Guide to Historic Plymouth*:

> *The Pilgrims first began laying out the street before Christmas in 1620 after disembarking from the Mayflower, allegedly on nearby Plymouth Rock. The original settlers built their houses along the street from the shore up to the base of Burial Hill where the original fort building was located and now is the site of a cemetery and First Church of Plymouth. Town Brook is adjacent to the street and provided drinking water for the early colonists. Governor William Bradford, Dr. Samuel Fuller, Peter Browne and other settlers owned lots along the road. The famed First Thanksgiving was likely held nearby in 1621. In 1823 the street was named Leyden Street after the city in Holland that offered the Pilgrims refuge before coming to America. Leyden Street, as it looked in 1627, has been re-created at nearby Plimoth Plantation. Although other streets such as those in Jamestown, Virginia, were used intermittently, Leyden Street has been used continuously since the original settlers built houses along the lane.*[46]

Leyden Street has seen the best of times and the worst of times. Patrice calls it a street of oppressive emotion and overwhelming grief. Replacing the homes of the Pilgrims are stately mansions, a few of which have been renovated into apartments. One such house was the site of the vicious 1996 murder of a woman whose husband killed her and hid her body in the attic.

Vicki said she has always wanted to investigate the reported hauntings of that house but has never had the opportunity to go in. "In all the years I have given tours, I've noticed that nobody stayed in that apartment for more than a few months," she said. "Now there is a tenant in that apartment that has been there a few years. They are either oblivious or fearless!"

According to newspaper reports in Plymouth's *Old Colony Memorial*:

> *Colleagues knew something was wrong when* [the victim] *never made it to a friend's wedding in early November. And once her husband, Victor, started lying about why she never returned to work after the Veteran's Day weekend, friends and relatives alike assumed the worst. But convincing authorities that something was terribly amiss proved a frustrating challenge until relatives discovered blood-soaked towels under a mattress in the couple's downtown apartment Friday. On Saturday, a police dog located* [the victim's] *body, tightly wrapped in bedding and plastic, behind a wall in the attic of her home….And by Sunday afternoon, prosecutors had obtained a warrant for Victor Cardarelli's arrest on a charge of murder.*[47]

It was a shocking and horrific crime. The victim was described by all who knew her as "an elegant lady" who "was a wonderful, kind, and

Leyden Street today, looking east. *Patrice Hatcher Photography*.

caring person."[48] A nationwide search led to plans to air the story on the syndicated, nationally broadcast crime show *America's Most Wanted*. Victor A. Cardarelli was captured by law enforcement officials on February 4, 1997, at the Resorts Casino Hotel in Atlantic City.[49]

Following the disappearance of his wife, Cardarelli made his way to Florida to visit his mother at her mobile home park. She told sheriff deputies that her son was headed to Texas.[50] A frequent gambler, Cardarelli went instead to Atlantic City. Flyers of the victim and Cardarelli had been distributed throughout Atlantic City. His casino loyalty reward card was what tripped him up. An astute cashier recognized Cardarelli when he tried to cash out the remaining $236 in his account.[51]

The entire greater Plymouth community was shaken that such a ghastly crime had happened to such a lovely lady and on one of the most historic streets in America. In addition, the victim's family, neighbors and concerned citizens were dismayed that multiple searches of the house and the attic did not yield any clues as to where her body was. The victim was not found until January 11, 1997, more than three full months after she had been reported missing.

A neighbor, Diane Knight, who lived across the hall from the victim in the Leyden Street house, was interviewed by *Old Colony Memorial* reporter Rich Harbert. She told him that "she and one of the victim's sons searched the attic [a month prior] without success. Knight said she even looked into the crawl space where [the victim's] body was ultimately found, but decided against poking through the personal belongings that were hiding the body of her friend. 'I was within inches,' she said."

The newspaper account goes on to say that the pair "focused their search instead on a hideaway in the attic that, according to local legend, had been used as part of the underground railroad to hide runaway slaves." Even while searching for the missing victim, Diane Knight held on to hope that her friend and neighbor would return. But that was not the case when the victim's body was found by cadaver dogs "wrapped in bedding and plastic in a crawl space under the front eaves of the building, just above her own second floor apartment." The cause of death was reported as multiple blunt force trauma.[52]

Evidence gathered by detectives showed that the defendant gambled, used the victim's credit cards and depleted their joint financial resources after the murder.[53] "I'm in shock. It's still just starting to sink in that I lived there for two months with her up in the attic like that. She didn't deserve to be chucked in a corner like that," said Knight, who moved from her

apartment a week before the grisly discovery. "She was a really nice person. She didn't deserve what she got."[54]

In 1999, Victor A. Cardarelli was convicted of first-degree murder of his wife and sentenced to life in prison.

Vicki shared her knowledge of the crime and the subsequent stories of a haunting in the house. "I understand that the murder scene was their bed. He was captured allegedly gambling on her credit card." She added, "I heard that after the investigation was complete, the movers came to dispose of items from the apartment. They left the box spring propped up at the dumpster and planned to take it to the dump on their next dump run. When the movers returned to get it, it was gone. If the story is true, someone out there has that box spring mattress."

She continued, "There are two spooky stories attached to the Leyden Street house. The first is about a schoolteacher who lived there and died of an asthma attack, having never had a medical history of asthma."

"The second ghost story attached to the house involves the murder victim. Supposedly, the victim was a huge fan of the 1970s television show *Little House on the Prairie*. Tenants in the apartment have reported that their television would turn on by itself in the middle of the night, and that the TV show reruns being broadcast were…you guessed it…*Little House on the Prairie*," reported Vicki.

Interestingly, the victim's neighbor from across the hall, Diane Knight, told reporter Harbert about what she had witnessed and overheard when the police were searching the missing woman's apartment. "[She] remembers the search and says she sympathizes with the police. 'I could hear them reading the titles of their movies. One was *Little House on the Prairie*. They appeared like really good people. [The police] had no reason to suspect anything.'"[55]

Another interesting connection to the haunting occurred when I casually mentioned the murder and stories surrounding the house on Leyden Street to one of the subjects of this book. While interviewing James, the young man who lives in the purportedly haunted house described in chapter 7, he reported that one of his friends lives in an apartment in the Leyden Street house. When I mentioned the name of the defendant, the EMF (electromagnetic field meter) lit up and spiked to red, 20+ mGs (milliGuass), which is the highest level on the K-II meter's register.

6

ENTERTAINMENT

Why do 1.5 million people visit Plymouth every year? Because there is so much to do here! Plymouth has great restaurants, an exciting arts and entertainment scene, a state park for hiking and biking, eleven golf courses, beaches, a scenic waterfront and, of course, the history.

I would be remiss if, prior to taking the reader into the downtown entertainment scene, I did not mention Myles Standish State Forest, one of Plymouth's natural wonders. With twenty-six square miles of pitch pine and scrub oak forests, this site is one of the largest protected pine barren areas in the Northeast. Bordering Plymouth and Carver, "the Forest" has sixteen ponds, hiking trails, bike trails, horse trails and campsites. This pristine conservation land is a very popular place for fishing and birdwatching.

Heading back downtown, who wouldn't want to do some antiques shopping in one of America's oldest towns? Plymouth is the place to go. There are a number of eclectic shops with everything from knickknacks to furniture. Browsers usually become buyers, and it is a rare occasion when someone goes home empty-handed.

In the twentieth century, nearly every town or city center had an F.W. Woolworth, and nearly everyone of a certain generation has memories of the lunch counter and of shopping for school supplies, clothing, household items and just about anything else, including goldfish and birds!

Main Street Antiques now occupies the former Woolworth building in Plymouth. The question is, does something or someone else also occupy the

Pond in Myles Standish State Forest. *Patrice Hatcher Photography.*

building? There is a well-worn story about the Woolworth building—is it true, or just part of the fabric of legend and lore?

There are a couple of versions of the story, which is passed around on ghost tours and among those interested in the paranormal. According to one version, in the 1920s, the owner of the building, despondent over financial troubles, hanged himself from the second-floor rafters or shot himself on the second floor. The second version recounts that the last manager of the Woolworth had his throat slit and died on the second floor, but his murder was covered up to make it look like it was a suicide.

I have not been able to verify either version.

According to psychic Patrice Hatcher, there is something there at the old Woolworth building.

"Every time I go up to the second floor, I trip on the stairs," she said. "Something prevents me from going up there. The sense I get is that something happened up there that is more violent than suicide."

Looking to get a bite to eat? One of the most popular restaurants in the downtown district is Sam Diego's Mexican Cookery and Bar. It is housed in the historic and architecturally interesting former firehouse no. 1. It's

Tex-Mex at its finest, including monster margaritas. Patrons can choose indoor or outdoor dining. Either way, the atmosphere is fun and festive.

Staff at Sam Diego's do not always share the sentiment that their workplace is full of frivolity. Many of them claim that the restaurant is haunted, with the basement the center of activity.

One of the bartenders shared her experience: "At night, when you are working with the kegs in the basement, you see and hear things and you feel like you are not alone. It's really weird and spooky down there. One of the other bartenders thought she saw a dog in the cellar."

"It's not just the basement, though." She continued, "I have had glasses literally fly off the hanging racks at the bar, and I have heard people say the lights flicker at night after everyone has left."

After lunch, dinner or drinks, there's plenty to do in downtown Plymouth.

The performing and visual arts are alive and well. Simply put, there is something for every interest and taste. Take a stroll downtown on any given night of the week along the multi-block stretch of Court Street, Main Street and Main Street Extension and you just might have a hard time choosing among the many activities, including listening to live music at one of the many restaurants or bars, viewing an exhibit at an art gallery, enjoying dinner theater and taking in a performance by the South Shore's premier choral group, the Pilgrim Festival Chorus.

At Memorial Hall on Court Street, the military history of our nation is on display and honored in the Hall of Flags, in a museum maintained by the American Legion and at monthly meetings of the local chapter of the Disabled American Veterans. Its twelve-hundred-seat auditorium hosts the Plymouth Philharmonic Orchestra, which just celebrated its 101st season. The "Phil" has been playing to packed audiences in the hall since it opened in 1924. Known for a professional orchestra experience, the Phil's performances sell out quickly, especially its Holiday Pops! and Spring Pops! concerts, which in recent years have featured popular artists such as Rockapella and Livingston Taylor, among others.

Its storied history is varied and diverse. Throughout the years, Bob Dylan and Twisted Sister have taken the stage at Memorial Hall; wrestling and cage fighting have whipped fans into a frenzy; and families and loved ones have made memories together at graduations and weddings.

There's the Plymouth Center for the Arts, where the visual arts have been celebrated and exhibited since it opened to the public in 2007 in

two historic buildings on North Street, the 1902 Russell Library and the eighteenth-century Lindens Mansion. Art, photography, pottery, ceramics, writing classes and workshops for children and adults are held in the center's lower level. From time to time, local theater groups perform in the intimate setting of the library and community groups hold meetings there. Exhibits are open to the public all year long, and the center presents its Juried Art Show annually.

Head south down the road a piece to the quiet, seaside neighborhood of Priscilla Beach. There, visitors find one of the most historic, influential and unique theatrical training grounds in the country, the Priscilla Beach Theatre. Thanks to its founder, Dr. Franklin Trask, this theater invented "summer stock in a barn" in 1937. Over its eighty-year history, hundreds of young actors have perfected their craft, performed to delighted audiences in its two-hundred-seat theater and sixty-seat performance space and lived in cabins at the wooded complex. Priscilla Beach alumni include well-known stars of stage, film, television and radio, including the following: Gloria Swanson, Veronica Lake, Paul Newman, Pat Carroll, Dan Blocker, Jean Seberg, Kitty Winn, Robert MacNeil, Peter Gallagher, Rob Reiner, Estelle Parsons and Jennifer Coolidge. The theater's beloved caretaker for more than fifty years is actor, director and host extraordinaire James Lonigro, aka Geronimo Sands.

Today, the newly restored barn and grounds welcome a new generation of performers and audiences. A popular youth workshop program for youngsters ages six to seventeen is offered three times a year. The exceptional "Broadway in a Barn" Summer Stock Troupe performs Broadway-quality plays and musicals to sold-out audiences all summer long. Well-known regional actors perform in musicals, comedies and dramas in the spring and fall.[56]

Back downtown, the Spire Center is *the* premier venue on the South Shore to see internationally recognized musicians, regional community theater and dance. Located in historic downtown at 25½ Court Street, the Spire Center was built as a Methodist church in 1886 and then served as the Jewish Community Center for Congregation Beth Jacob.

This architecturally significant and beautifully restored church, complete with original woodwork, stained-glass windows and original pipes from when the church had an organ as musical accompaniment for hymns and religious services, is a site to see. Its soaring interior is three stories high and offers outstanding acoustics and state-of-the-art lighting and sound systems in a unique and elegant setting.

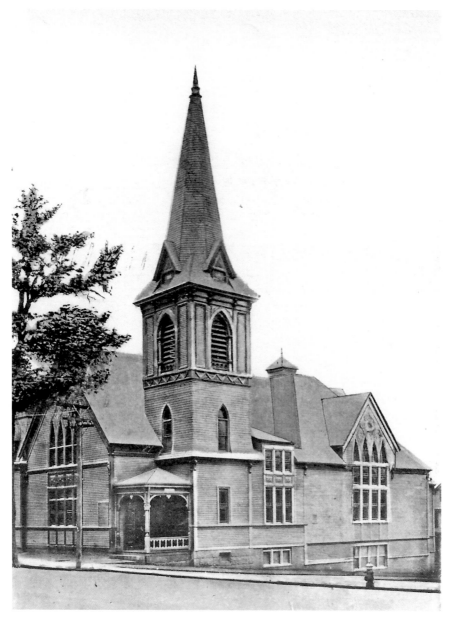

Vintage postcard of the Methodist Memorial Church at the corner of Court and Brewster Streets, circa 1950. Today, it is the home of the Spire Center for the Performing Arts. *The Metropolitan News & Pub. Co., Boston & Germany.*

The variety and array of performers who have taken the Spire's stage include Rita Coolidge, Shawn Colvin, Peter Yarrow, Patty Larkin, Jonathan Edwards, Lori McKenna, John Waite, Kathy Mattea and Peter Wolfe. All year long, one can catch a band, a play or a musical; view the photo gallery and memorabilia from artists; and enjoy entertainment not available prior to the Spire's opening in 2014. Plymouth Community Theatre produces four to five outstanding shows there per year, Shakespeare in the Summer is a popular draw and the annual jazz festival sells out.

The Spire Center also offers practice space for theater groups and musicians, educational workshops focusing on the arts, multicultural activities, book signings and space for community groups to meet.

Located in the Spire Center's lower level is Seasound Recording Studio, a full-service digital recording studio and communications service. Owner Mark Bryant and his trusty assistant, Dot McDonough, put in lots of hours at the Spire as sound engineers producing CDs, collaborating with other musicians, playing music, doing voiceover work and collaborating with headlining performers before and after shows. Burning the midnight oil is the norm in their line of work, so it is not unusual for one or both of them to be alone in the building after the last curtain call. In fact, the quiet and solitude can sometimes be a welcome and much-needed respite from the hubbub and frenetic activity of live performances. Technical, detailed work can be completed without interruption...sometimes. What or who they have encountered on those evenings is beyond reason and explanation—but unmistakably real and clear.

Mark is no stranger to hauntings. Between 1985 and 1987, he lived in a haunted house in nearby Brockton. It wasn't an old house, but rather a split-level raised ranch house in a regular neighborhood on a regular street. "It was the energy that was different," said Mark. "You could feel the sound and energy."

Even more startling was an experience Mark and his brother had involving a lovingly cared for antique guitar, specifically a 1946 Gibson L6, displayed in their home. The guitar had belonged to their father. "We were reminiscing about people who had passed, and the pride Dad took in caring for that guitar when out of nowhere, there was a single strum of three strings on the guitar," reported Mark. "It was eerie, but not frightening, and both my brother and I knew that it was Dad just sending us a message of recognition."

His experience at the Spire Center after dark is quite different.

From their studio in the basement, both Mark and Dot have heard what sounds like one person walk across the floor above them from the lobby at

the front of the building (which now also serves as a lounge and bar area), to the former nave, which is now the seating area for performances, to the former sanctuary, now the stage.

The clear sound of footsteps happens only at night, sounds like one person and happens after the theater group in residence on the third floor has left for the night. The doors have been locked and the lights put out. No one else is in the building except Mark and/or Dot. They've checked for intruders and other possible causes.

"It started in June 2013 and happens on calm nights, usually between 9:00 and 10:00 p.m.," said Mark. "The footsteps are very distinct, continuous in their path from the front of the building to the back, and loud, like the steps of a 160- to 180-pound person," he added.

Dot describes herself as a "tough chick" and said that not a lot phases her. It is evident, though, that she was shaken to her core one evening when she encountered a very dark energy. "I was working while listening to the artist Prince, whose music can be somewhat provocative, when I first heard the footsteps upstairs," she said. "I went up the stairs to the lobby to check on the cause of the noise, saw nothing and returned back downstairs."

"When I got to the bottom of the stairs," Dot continued, "I felt it. I ran out when someone, or something, muffed my ears." She recalled, "I said, [expletive] this! I am out of here!"

Dot says she now makes peace with the entity when she approaches the stairwell. Even when she feels like it wants her to get out, she musters the courage to stay. She changed her playlist at work, too. It no longer includes music that might be considered sinful or irreverent by the building's former preachers and parishioners.

There is another "hot spot" of ghostly activity at the Spire. Mark and Dot have both felt it, as have some of the headlining performers. It's in the stairwell to the left of the stage, and while there have been no visualizations, the energy is so elevated that it caused one internationally known, award-winning performer who asked not to be identified to remark, "Boy, this place is haunted!"

Mark senses that it is a male figure that inhabits the Spire Center. There could be others, though, as the church itself has been a public building. Thousands of people in life and in death have passed through its doors in its 130-plus-year history. He has taken to leaving on a pair of red and green lamps backstage all night just for the spirits.

Ironically, in the theater world, a lamp left burning on stage all night is called a ghost light. Part superstition, part practicality, the purpose of

ghosts lights, according to a story published in *Atlas Obscura*, is to protect a theater building from mischievous acts by ghosts when no one else is around. Practically speaking, it also keeps burglars at bay. One legend attributes the ghost-light ritual's transformation to standard practice to an incident in which a trespasser broke into an empty theater late at night, fell and broke his leg, then sued the theater for damages.[57]

Regardless of the origin of the ghost light, two ghost lights, not one, are lit every night at the Spire Center for obvious reasons.

There may be another presence watching over the people on the streets of Plymouth late at night.

There is a tale passed around in downtown Plymouth about the ghost of a policeman who walked the beat in the 1960s. Many people believe this patrolman to have been Tony Gallucci, because there is a plaque dedicated to his memory in an alley on the west side of Main Street. The plaque reads:

GALLUCCI WALK WAY
IN MEMORY OF
ARMANDO (TONY) GALLUCCI
MARCH 22, 1913–MAY 6, 1984

A POLICEMAN'S PRAYER
Dear Lord, Be with me on my beat
this day and every day. Grant
that each weary block I walk
may ease a brother's way. Let
me be kindly to thee old and to
thee young be strong, but let me
triumph over those whose acts
are cruel or wrong. And when
my own last summons comes and
I stand in your court, Lord,
may my rest with you be long,
my punishment be short.

FROM ALL HIS FRIENDS

Tony Gallucci did indeed walk the beat downtown and was a popular and trusted figure in the community. *Plymouth's 1984 Town Report* honored him after his passing:

> *ARMANDO A. GALLUCCI, 1913–1984*
> *Appointed to the Police Department, "Tony" served with distinction as a permanent-intermittent patrol officer until his retirement. The Town will always remember his diligence and effectiveness at keeping vehicle traffic flowing smoothly in Shirley Square on Friday nights with constant hand signals, an ever-present whistle and an occasional shout. Tony was also very active in community events and social club activities. The dedication to his professional and social responsibilities was greatly admired by all.*[58]

Sadly, a police officer died in the line of duty in the 1960s. Patrolman Paul David Murphy had been on the Plymouth force for two years when, on January 28, 1965, he was killed. The manner of death was recorded as a fall down an icy set of stairs leading from School Street at the east side of Burial Hill to Main Street.

Perhaps Officers Gallucci and Murphy watch over the people of Plymouth and keep the downtown safe for those who work, live and enjoy all that Plymouth has to offer.

7

A Tale of Two Houses

This is a tale of two houses—well, one house, really. It is the house one sees from the outside, and the house one knows from the inside.

Built circa 1812, this Federal-style Cape Cod house looks a lot like others in the neighborhood. It boasts classic lines, "good bones" (as they say in the real estate business) and a historically accurate and well-maintained exterior. Cheerful and inviting, the home is located just outside Plymouth's historic district on a manicured lot with tall, broad maple trees that are as old, or older, than the home itself. These strong sentinels provide a canopy of emerald green shade in the spring and summer and fiery red and gold cover in the autumn. Winter here is cold and gray, and the wind off Cape Cod Bay casts icy, salty spray against the home's eastern front.

Over its more than two-hundred-year history, this house has served Plymouth residents in many ways. Built as a home, it has remained so over the years while also alternating between mixed-use office space and apartments. Little is known of its history except that it is rumored to have been a stop on the Underground Railroad in the nineteenth century. It boasts the cozy comfort of seven fireplaces throughout, original post and beam construction and the wistful charm of a bygone era.

But if you ask those who have lived and worked there, you may find that the house boasts something else. A ghost. But what kind of ghost? It depends on whom you ask.

A former secretary says that it is a friendly ghost that liked to play tricks on people in the office. Little things, like a stapler or a box of paper clips, would

Plymouth's stormy harbor. *Patrice Hatcher Photography.*

go missing and then reappear somewhere else. This ghost was playful, like a child. Consensus in the office was that the ghost is of a little girl, a happy kid who must have lived there sometime in the home's past who garnered attention from the office staff by performing innocent pranks, just like any small child would.

Seems harmless. In fact, during a renovation a few years back, a child's shoe was found inside one of the interior walls. Sends a shiver down your spine, right? Well, it shouldn't. Concealing shoes in homes was common practice in most European countries in the late Middle Ages, lasting to the revolutionary age, roughly the three hundred years between 1500 and 1800.

This practice was so popular in England that the Northampton Museum and Art Gallery in Northampton, England houses the largest collection of historical shoes in the world and "maintains a Concealed Shoe Index, which by 2012 contained 1,900 reports of discoveries, mostly from Britain and almost half from the 19th century. The overwhelming majority have been worn, and many have been repaired. Most finds are of single shoes, about half of them belonging to children." June Swann published an analysis of the Museum's collection in 1996, which "reveals that the most common

place of concealment is the chimney, fireplace or hearth (26.2 per cent), followed by under the floor or above the ceiling (22.9 per cent), and almost as many concealed in the roof. Shoes have also been found around doors and windows, under the stairs, and among the foundations." In England concealed shoes have been discovered in many types of buildings: country cottages, town houses, manor houses, hospitals, workhouses, factories, public houses, and two Oxford colleges, St. John's and Queen's. They have even been found in ecclesiastical buildings, including a Benedictine monastery in Germany and a Baptist church in Cheshire, England.[59]

The custom seemed to die out during the twentieth century, but it makes sense that western European settlers to New England, particularly those from England, would incorporate this tradition into the fabric of their dwellings. But why?

Simply put, people hid shoes within the structure of buildings because they were superstitious. Hidden shoes were like the apotropaic magic charms or talismans of ancient Greece. They served a dual purpose: to ward off evil and to bring luck.

It was believed that a witch or demon would be attracted by the aroma of an odiferous human foot, follow the scent into the shoe and find itself trapped and unable to reverse course, thus rendering the spirit powerless to wreak havoc on the family in the house. Folklore surrounding shoes speaks also to aspirations of good fortune for the home's occupants and prosperity regarding domestic matters. In some circles, they were even used as fertility charms. Remember the old tradition of stringing shoes to the back of newlyweds' cars before they drive off to their honeymoon? There's a good chance that this ritual is rooted in that superstitious custom.[60]

Did the shoe found in this cozy Cape-style home ward off evil and bring luck to all who enter? Again, it depends on whom you ask. A former resident did not encounter a spirited sprite like the one described by the former secretary. Instead, this person described something menacing and dark. "It was more of a feeling, a sense of dread, anxiety and fear that I felt when I lived there," said the former resident, who wished to remain anonymous. "I moved there to get a fresh start, but I barely had the chance to unpack even a few boxes before a series of unfortunate events happened that prevented me from settling into my new home."

A perfect storm of personal and familial tragedies converged on the man within his first few months in residence. Coincidence? "Without a doubt, the tragic occurrences in my personal life were not because of the

house," he said. "But instead, it was in the aftermath of those experiences that I just could not seem to acquire any sort of comfort there. I wanted to be able to seek refuge in my new home, make it my own, but it just never felt like home to me."

"I just chalked it up to a bad, yet merited under the circumstances, case of the blues, and that it would get better," he added. "But, it just never did."

"At first, it was the bedroom," he said. "I couldn't sleep in there without the radio on all night because it seemed noisy to me." When asked to describe the noise, he replied, "It's hard to describe. It was just 'noisy' like chatter, but not voices, more like an undercurrent of noise."

"The bathroom, it felt heavy in there," he added. "Really heavy."

"What is really strange is that I just thought it was me, that I was going through a tough time," he said. "But, now I think there was more to it. The new residents contacted me shortly after they moved in because they wanted to know if anything happened to me like what was happening to them."

"What was happening to them?" I asked.

"Well, from what I have heard, it's more than a feeling," he replied.

I visited the nice young couple who live there now, Elizabeth and James (last names omitted by request), at their home to find out just what was going on there. They have reported that unusual items are found on and underneath their coffee table, things that just shouldn't be there, like torn paper, dirt, hair, flowers and even a cactus plant.

James said, "When I first starting noticing things, it was when I would get home late from work. It started off very early with dirt and lint types of things being on the coffee table when we would get up in the morning."

Elizabeth continued, "One of the times we found an old flower under the bottom part of the table, which is just an open shelf. I'm assuming it is from the plants in the big bay window, because of the type of dirt that ends up on the table, but there are no flowers in the window, only leafy greens."

"But," she said, "before we had the plants, there was a crispy, white wildflower on the opposite end of the coffee table resembling a small daisy. Like I said, that was before we had any plants in here. How did that get in here and on the coffee table?"

"Our friend had spilled a glass of water on the coffee table, and I was cleaning it up," said James. "Then I noticed all the dirt and the hairs. The funny thing is, my friend won't come here anymore."

While interviewing Elizabeth and James and investigating the perplexing activities, I looked up at the ceiling above the coffee table. "I did the same thing," said James. "That is the first thing I did when I found the mess on the

coffee table. I looked up, but no, there is nowhere for anything to make its way through a solid ceiling."

Indeed, it is very solid.

"Mice?" I asked.

"We thought of that," Elizabeth and James said in unison.

Elizabeth continued, "Of course, this is an old house. There are mice in old houses, but this is not what a mouse could do, and the items are nothing they could move. And, why would they put the stuff on the coffee table?"

After the mess is cleaned up, Elizabeth and James very often find something there again the next day. The cactus plant was returned to its original spot on the windowsill by human hands; to everyone's relief, it hasn't found its way back under the coffee table—yet.

"There's dirt sprinkled around the table, in the same spot, and a very specific spot," said James. "Thick black hair, four inches long, like animal hairs are on the table."

The previous tenant confirms that there hasn't been an animal in the house for at least ten years.

"It's the same exact thing in the same exact spot," said James. "It is the same every day. Three to four inch long hair. The hairs never appear anywhere else except the coffee table."

"I told my mom that weird things were happening here," said Elizabeth. "I told her about the dirt that was sprinkled around the table, and that is when my brother got involved."

Elizabeth's brother purchased a night vision camera from an online retailer. "We set it up in the corner of the living room to cover all of the living room, the kitchen area, and the front door," said Elizabeth. "My brother recorded using a remote application on his phone from 12:00 midnight to 7:00 a.m. every night for two weeks. We chose that time because most of the activity happens from 12:00 midnight to 7:00 a.m."

Nothing happened.

"For two weeks prior to him setting up the camera, there was activity every single day and night," she said. "Then when the camera went up, nothing. Not one single thing happened. He could see our headlights when we pulled in the driveway. He could see when we came in the front door. He could see us in the apartment, but nothing else. There were no ghostly activities. There weren't any funky things going on in the background of the video, because we checked."

When James, Elizabeth and her brother removed the camera from the residence, they reported that dirt appeared on the coffee table the very next night.

By this point in the interview, I had pulled out an EMF (electromagnetic field meter) and turned it on.

"I feel like when it knows we are talking about it, it won't light up the meter," said Elizabeth. "Just like it wouldn't come out to be filmed when we had the night vision camera set up."

Just like the previous resident, they hear noises that are more pronounced at night, and they get the feeling they are not alone. Friends and family members have experienced it, too. Something or someone is there with them.

"Another thing that happened shortly after we moved in was banging on the bathroom door, but only when you'd be home alone," she said.

James said, "Once I heard it when she was asleep. I haven't heard it in a month or so, so I'm not sure what was going on behind that. I heard two distinct knocks on the door, like when you knock on a door to find out if someone is in there. I asked Elizabeth, 'Did you go and knock on the door?' She said, 'No.' She was in bed sleeping."

Elizabeth continued, "Once when I was cleaning the bathroom, I heard two knocks on the door. I looked out, and no one was out there. Also, things fall in the shower all the time."

"The closet," said James. "I feel very strange in there. I grab what I need and I am out of there quickly."

"I keep every light on when I am home alone," said Elizabeth.

"I watched my parents' dog here at the house. James was away skiing at the time, so I was alone with the dog," she said. "And just to clarify, my dog does not shed, so there is no way that is his hair."

"It was the first night that I was home alone," Elizabeth continued. "My friends came over that night to keep me company. The dog was happy, comfortable and playful because he knows them. When they left, the dog started to behave differently. At first, he just started acting out like any other dog," she said. "It was a new space to him, so he was sniffing around, getting acquainted. The, he started acting totally weird. He kept jumping onto the back of the couch and was looking back, towards the bedrooms. So I shut the door to the bedrooms."

Later that night, it got scary.

"When we went to bed, the dog would not settle down. I actually woke up in the middle of the night to him standing at the end of the bed growling at something across the room. When he was standing at the end of the bed he was growling in the direction of the fireplace," she said. "I got so scared that I grabbed the dog, pulled the covers over our heads, and we—me and the dog—eventually fell asleep under the covers."

"There also seems to be a noise in the bedrooms," said Elizabeth. "It sounds like there is a radio on, muffled, lower, people talking, but you can't make anything out."

James added, "When she works late, I just stay up because I am afraid. I watched the bedroom door open once on its own. I was afraid."

"Another time, I was here alone in the bathroom, and I was waiting for my friend to come pick me up," he said. "I heard a loud bang on the door, like a fist hitting it. I opened the door, and no one was there. It wasn't my friend, because he was sitting in his car in the driveway."

"Noises and bangs have happened to him, but the little things happen to me," said Elizabeth. "But here was one time that I was really scared." She added:

> I am a bartender in downtown Plymouth. I get home late from work at three o'clock in the morning. I got a glass of water, I was trying to calm down from a busy night at work, and I went to bed.
>
> When I got into bed at around 3:30 a.m., as soon as I settled in I heard what I thought were the coasters on the coffee table clinking. It sounded like someone picked them up and stacked them on top of each other. It is a very prominent sound because they are heavy granite coasters.
>
> After I noticed that sound, I was listening intently and then heard what I thought was the cabinet opening and closing and then another cabinet open and close. I can assure you that all the cabinets were closed when I left the kitchen to go to bed. It then sounded like someone walked down the hallway and opened the first door before you enter the hallway into the bedroom. I sat up because I thought someone was going to walk into the bedroom!

No one came through the door, nothing else happened and she has not heard any similar noises after that terrifying night.

Like the previous resident, there are moments when Elizabeth doubts what she experienced. She said, "I'm still a little skeptical about hearing the noises that particular night, because I don't know, maybe I was just really tired after a long night of work."

But another thing Elizabeth and James share with the previous resident are bad dreams—vivid, terrifying dreams. James explained:

> I have had very weird dreams since moving here. Horrifying dreams. I feel like I am in another dimension. I shoot up in bed and yell. I am so rattled every time I wake up after a dream in this house.

I had a dream where I was having an out-of-body experience. It was a lucid dream. I felt like I was in another dimension, then I shoot out of it, in tears, in terror. I was not even in my body. I know there was someone there with me. I got out of bed, was walking around the house, and then I was standing at the bed. I could see both of us, me and Elizabeth, sleeping in the bed. I got out of bed, I was walking through the apartment, and I knew there was someone there with me. There was a dark, male figure, and he was with me. I don't know what he was saying or doing. He was talking to me, and I retained all of this information all at once. I was back into my room at this point, and got back into bed, and shot up. I woke her up. It was by far the weirdest experience I have ever had. I was really confused about it. I have awakened from dreams in this house and I am in sheer terror.

"I definitely feel like I have had bad dreams, and wake up mad at James for no reason. I don't know why," said Elizabeth.

"We used to joke when we first moved in that this house was haunted," said James. "We know it is an old house. Is it a cliché?"

"So we waited to tell the landlord when we made our first rent payment," said Elizabeth. "She was very vague and said that some other people who lived here and worked here thought it was haunted."

"Mischievous, that's how I would explain it," she continued. "I think it [the spirit] is a little kid, because there are very childish things that happen. Think about what a toddler does. A toddler sticks their hand in a plant and makes a mess with the dirt and then throws it."

She added, "Any time the knocking on the bathroom door happens, we are out of sight. It is like it is a child that is saying 'Where are you, where did you go?'"

"Again, I will say, I don't even know how I feel about any of this stuff," said James. "After the dreams I felt terror, like I was in panic, and very afraid. When Elizabeth is working late, I am afraid to come home."

"When I think of there being a ghost here, I do think of it as a child ghost. It's the least intimidating thing that can be here. I don't want to think of some big, mean man here," said James. "That's intimidating. I live here! If we see something flying across the room or all the cabinets open, then that's another thing. But, I am comfortable here. It helps that we are here together."

He added, "None of the doors sit tight in this house because of its age and settling, but you can tell when it is a draft. When the door opens by itself, creaks loudly and then comes to a stop, that is different. Something fidgeting

with the door latch, or knocking or banging on the door, that is very different then a door affected by a draft."

"Once things start flying, that's all, we're out!" he said jokingly.

The basement in the house is an average basement for its time. In the early 1800s, most basements were dug to accommodate a dwelling above it and a root cellar at the back. Sometimes a lean-to was added to provide shelter for chopped wood for heat and cooking fires. The root cellar typically stored winter root vegetables like turnips, cabbages, parsnips, brussels sprouts and beets. The cellar in this particular house is located over the original, traditional Cape Cod post and beam construction structure, built of fieldstone and mortar. Some say it could have been a stop on the Underground Railroad. But like many Undergrcound Railroad stops, nobody knows unless they have to know.

"I can understand what the previous resident of the house meant when he talked about having depression while living in this house," said Elizabeth. "With bad things, or when a bad thing happens, it feels heavier here in this house. It is a different kind of thing than anything I experienced before. It's an emptiness, it can feel very hollowing. If James wasn't here, maybe I would wallow in it, but when someone else is here, like with the knocking and other experiences, it doesn't feel as bad."

"I feel better in the newer part of the house than the older part. If I am home alone," said Elizabeth, "I have the door to the old part of the house shut. I consider this part of the house my house, and I am safe over here."

Further investigation of the house reveals that it is older than originally thought. Because there was a fire and the records at the registry of deeds were lost, and because the architectural and landscape evidence indicates an earlier period, the dwelling's establishment is probably closer to the 1780s, or at least some structure was on the land at that time.

"I am trying to picture how that dirt was getting there on the coffee table. Is it floating across the room?" asked James. "The flower, it's not like one of them over there that dried up and died from a plant we have, and we know that the flower wasn't there at the time anyway. How could the flower get there?"

Psychic Patrice Hatcher has another explanation.

"A lot of energy is expended in moving things," she said. "Think about it. What do we have to do as human beings to move something? We have to use our brain to create the thought, and then our nerves, muscles, ligaments and bones to move, and then to have strength to pick something up to move it."

"The amount of hair that James and Elizabeth found on their coffee table, the length of the hair at about four-inch-long clumps, and the length of the dirt on the coffee table, also at about three to four inches long, indicates to

me that this is an animal haunting," reported Patrice. "Add to that the time that the hair and dirt appeared, between 12:00 midnight and 7:00 a.m., that is when nocturnal animals are about," she added.

"It seems like whatever is haunting that house is acting in a territorial manner," she said. "Perhaps it is a bear or a coyote or a dog. The hair and paper appearing seems like it is an animal building a nest, like a mother animal building a den and protecting her young cubs or pups. A den keeps coming into my mind."

While Town Square is ground zero for where the Pilgrims dwelt, their original fort was on the hill that is now Burial Hill. The Native American settlement would have been west of the Jenney Grist Mill. The Native Americans would have traversed this area, but the Pilgrims would have come here on a less regular basis. By seventeenth-century standards, the land this house stands on would have been considered a wilderness.

By the time this particular house was built, the 1677 Harlow Fort House was an antique at approximately 135 years old. The area surrounding the house is wooded and hilly, a perfect location for dens for coyotes and the like. By the time the house was built in the late 1700s or early 1800s, the house was considered less remote but still outside of town.

"The tapping on the bathroom door is like something trying to gain entrance," Patrice added. "In my head, I hear a low growl. The frightening feelings people have at the house, the night terrors, the subconscious can recall a traumatic experience and pull things out like that."

Patrice went on, "A den, a dog or coyote, a mother dog keeps coming into my head. It is very protective, like a mom animal not letting go. I envision a one-on-one confrontation of some sort, a challenge, and she wants whatever it is to back off. It feels like maybe the animal lost her babies."

"Ask the people who live there now to clear out the energy." She added, "Or they have to come to terms with living in that space with that type of energy."

When told of the psychic's advice, Elizabeth said, "Curiosity killed the cat, so maybe we should just leave it alone."

At that point, the EMF meter that I had turned on earlier went off and lit up like a Christmas tree.

The owners still have the child's shoe found in the wall when renovations were made to the historic structure many years ago. Is it time to take the concealed shoe superstition one step further, so to speak? Perhaps replacing the shoe in a wall or in one of the chimneys will lead the malevolent spirit into being captured and bring relief to the people who live there. At the very least, a good sage "scrubbing" is probably in order.

8

NORTH PLYMOUTH

Plymouth is a town of village centers, five of them to be exact—Downtown, Manomet, Cedarville, West Plymouth and North Plymouth. While there are many villages and neighborhoods of distinct character within the original five village centers, zoning bylaws of the 1960s helped to maintain the village center concept for the town. Many believe that this concept helped the town maintain its original rural character.[61]

North Plymouth borders Downtown Plymouth at Knapp Terrace, Olmstead Terrace, Standish Avenue and Liberty Street on the south; U.S. Route 3 on the west; and the town line of Kingston, Massachusetts, on the north. Cape Cod Bay serves as its eastern border.

North Plymouth is best known as the home of the Plymouth Cordage Company, once the world's largest manufacturer of rope. Founded in 1824 by Bourne Spooner, son of Nathaniel Spooner of the 1749 Spooner House (see chapter 2), the Plymouth Cordage Company's product was integral to ship building and rigging, maritime industries, commerce, trade, whaling, farming, manufacturing, military industries and wartime efforts. The company made special rope for oil-rig drilling and for any other industries that required the use of rope, binder or twine. Cordage had manufacturing facilities all over the world.

A ropewalk is an area of long, narrow, straight lines where hemp is stretched and laid to be twisted into rope. At the Plymouth manufacturing site, the ropewalk building was 1,090 feet long, with the ropewalk at 900 feet, long enough to twist hemp into 600 feet of rope.

The Plymouth Cordage Company was an innovator not only in the manufacture of rope but also in its company-sponsored benefits provided to its thousands of workers during its 141-year history. The company won a gold medal at the St. Louis World's Fair in 1904 for its corporate-sponsored employee benefits.

North Plymouth sprang up as a "company town," with company-built housing; company-created recreation, including baseball and basketball teams; onsite company day care; a library; and a free medical clinic. The Cordage Company's leadership were visionaries in terms of company benefits that would keep workers happy, healthy and loyal. North Plymouth essentially became its own town, with its own "main street" and shops, its own movie theater, parks, schools, educational and training activities and full-day kindergarten. The Cordage Company provided entertainment, recreation and education for its workers through the establishment of clubs, including sewing, dressmaking, carpentry, canning, basket making, drawing, English-language classes and a band.[62]

After the Civil War and through the early part of the twentieth century, the company grew with immigrant labor. Yankee, Scotch, English, Scandinavian and German workers were joined by Italian, Portuguese, Cape Verde and Azorean workers. The Plymouth Cordage Company was a virtual melting pot and, as a result, so was North Plymouth.[63]

By World War I, the company employed two thousand people. The population of the entire town of Plymouth at that time was twelve thousand.[64]

Times change, business changes and the Plymouth Cordage Company changed, too. After serving as a major supplier of rope and cord for the U.S. military in World War II, demand for Cordage's product dropped and production levels declined. In 1950, the Plymouth ropewalk was broken up and a portion of it moved to the Mystic Seaport Museum in Mystic,

The former Plymouth Cordage Company, now Cordage Commerce Center. This is a present-day view from the harbor. *Patrice Hatcher Photography.*

Connecticut. By 1965, the company had been bought out, and the mighty rope company closed.

Over the years, an outlet mall and shops, restaurants and offices have filled the former mill buildings. Demolition of many of the Cordage complex buildings has reduced the site to a few buildings on forty-five acres, but the businesses in those few buildings serve the greater Plymouth population well. Cordage Commerce Center is now home to medical offices and services, a large health and fitness facility, the University of Massachusetts–Boston, Quincy College, restaurants, offices for large and small businesses and a commuter railway station.

Readers are highly encouraged to visit the Plymouth Cordage Company Museum, located in the main tower building at 10 Cordage Park Circle in Plymouth. It is open Saturdays and Sundays from 12:00 p.m. to 4:00 p.m. The museum's docents have decades of experiential knowledge about the Cordage Company and Plymouth and are eager to assist visitors interested in the company's history, Plymouth history, labor history and genealogy. The numerous artifacts in the museum tell the story of 150 years of the region's history.

In addition to housing businesses that provide essential services to the greater Plymouth community, the site includes a marina. There are plans to build a large medical office building, and luxury waterfront condominiums are becoming a reality.

North Plymouth remains densely populated today. The Plymouth Cordage Company's well-built structures are now houses, duplexes and apartments that are home to about thirty-six hundred people within its three-and-a-half-square-mile area. It is rare to find a vacant parcel of land, unless it is a park or other recreational area. So, when a flat, buildable lot becomes available at a fair price in North Plymouth, one would expect it to be snatched up by a ready buyer. In one case, however, this did not happen.

"I have a friend," explained psychic Patrice Hatcher, "who owned a plot of land in North Plymouth.

> *He wanted to sell it. It looked like a perfectly good piece of land to put a house on, but he couldn't understand why no one, no builder, no young couple who would want a plot of land to build a house on, why no one wanted to buy it. People would come by and look, there were deals that prospective buyers put into place, and then the deals would fall through. It was odd, because it is in a great location with all the town amenities and services.*
>
> *So he asked me to go take a look at it, so I did!*

"Nice piece of land," I thought, and then it hit me. There was a Native American spirit attached to that piece of land and he was not moving! I told my friend, "Listen to me and take what I say seriously. You have one angry Native American on that site, and he will not leave. He is making it so no one will buy the land. You need to have the land cleansed and help this man on to a better place."

Shortly thereafter, I noticed that the piece of land sold. So the next time I saw him, I asked him what happened.

He said, "I did what you said, and it worked!"

Vicki Noel Harrington, owner of Spirit of Plymouth Walking Tours, lives in a house in North Plymouth with her family.

She told me, "When my son was eight years old, he was afraid of the attic doorway in our house. We had to put a bolt on the door because the door kept opening. He was petrified."

"During the day when the kids were at school, I would be downstairs doing housework, and I would hear the desk chair move in my bedroom upstairs," she added.

"Years ago, when I was up in the middle of the night with the baby, I used to see a shadow downstairs, and my older son saw it, too," she said. "He also told me he saw Native American Indians in the backyard, and he never went out there after dark," said Vicki.

"Native American Indians in your backyard? Really?" I asked.

"Yes, when he was younger he saw Native American Indians in the backyard," she replied. "But he says he doesn't see them anymore. Why?"

"Just a story I heard about a haunted plot of land that involved one angry Native American ghost who would not leave, but where he was is not anywhere near your house, and I heard he has since moved on," I replied.

Hmmm…

Vicki continued with the stories about her home. She learned some things that confirmed her suspicions that her house was and may still be haunted.

I found a woman online who grew up in the house, so I contacted her. She said the kitchen chairs used to move on their own when she lived there. She said the family would hear things move upstairs and that my bedroom was that of a previous elderly resident, who was a mother and a grandmother. She passed away up there in the bedroom.

Now that my kids are grown, nothing happens. Maybe the former owner has moved on because there aren't any children in the house to watch over

anymore. Or maybe someone close to her has passed on, and they helped her move along. I just know, sense, that she is not there anymore.

Vicki's passion is giving tours and sharing her knowledge of Plymouth's history with guests and visitors to the area. At the end of each tour, she asks guests to join her in a little incantation that will prevent a ghost from attaching to them and following them home. She asks people to wipe their feet and say, "Thank you, and you may not follow me home."

> *For whatever reason, even though I would say the little chant, I used to bring things—ghosts, spirits, things—home with me from the tours. Sometimes, my kids would use the map light in my minivan as a reading light, and inevitably, if I didn't check to make sure they turned it off, I would wake up in the morning to a dead car battery! It became my habit to check every time I left and locked up the car.*
>
> *One night, after one of my ghost tours, I loaded up my lanterns in the back of the minivan, drove home, locked up the car, looked back, and the reading light is on! So I went back outside, opened up the minivan, shut off the light, locked up, and as I was about to step in the house, I looked back and the opposite reading light was on. So I went back, shut off the light and yelled "Would you cut that out?!" It only happened that one time.*

"But there was another time when my kitchen curtain at home got torn off the window, it billowed out and was left torn and hanging," she said. "And then there was another time when I was having a problem with the horn in my car. It would go off as the alarm every now and then, but never when the keys were anywhere where they could be bumped to accidentally trigger the alarm. I asked it to knock it off, and it never happened again."

A private residence in North Plymouth is also purportedly haunted. Psychic Patrice Hatcher described the activities at a Victorian-era home located on Court Street on a hill across from a strip mall.

"I heard from someone who lived there that things would move on their own." She continued, "A flashlight that was left in one closet was moved to another closet. I was told that this was a common occurrence."

High on another hill on Allerton Street, not technically in North Plymouth but north of downtown Plymouth, stands the National Monument to the Forefathers. The monument was commissioned by the members of the Pilgrim Society and Pilgrim Hall Museum. It was designed by Hammett Billings (completed after his death in 1874) and dedicated on August 1, 1889.

Vintage postcard of the National Monument to the Forefathers. *A.S. Burbank, Plymouth, Massachusetts.*

This colossal statue stands eighty-one feet tall and is considered the largest solid granite monument in the world. It commemorates the virtues and values of the Pilgrim forefathers as seen through the Victorian perspective of the commissioning agents of the Pilgrim Society.

The National Monument to the Forefathers and the park where it stands is owned by the Commonwealth of Massachusetts. The state's Department of Conservation and Recreation oversees the maintenance and care of the monument and its grounds.

"Faith" stands atop the monument, holding a Bible with one hand and pointing to heaven with her other. There are four figures perched on her base: "Morality," "Law," "Education" and "Liberty." Marble reliefs depict Pilgrim scenes. Inscriptions on the panels include the names of *Mayflower* passengers, as well as a quote from Governor William Bradford's "Of Plymouth Plantation":

> *Thus out of small beginnings greater things have been produced by His hand that made all things of nothing and gives being to all things that are; and as one small candle may light a thousand, so the light here kindled hath shone unto many, yea in some sort to our whole nation; let the glorious name of Jehovah have all praise.*[65]

The commissioners of the monument dedicated it with the final inscription, which reads, "National Monument to the Forefathers. Erected by a grateful people in remembrance of their labors, sacrifices and sufferings for the cause of civil and religious liberty."[66]

James, the young man who spoke of the haunting of his own dwelling in chapter 7, told me that he had a childhood friend who lived on Allerton Street near the National Monument to the Forefathers.

"This was bad. This was really bad," he said. "My friend's parents owned the house, and there were a couple of apartments in it. They lived on one of the floors and rented out another. They moved because it was haunted. Their move happened quickly, and they left things behind because they just wanted out. On their last night in Plymouth, my friend's parents talked to my parents and told them that they were moving and why."

At that moment, when James spoke of the family having to move out of the house, my EMF meter spiked to red.

"From what I remember, they said, 'Don't think we are weird, but we have seen so many things in that house, we just have to leave!'" James said, "They didn't tell anyone but me and my parents."

"The mother and the daughter in the family would see full-body apparitions. It was just the mother and daughter who experienced the full-body apparitions." He continued, "The mother said a man in an old-fashioned suit would walk through the kitchen and the living room, then turn and look at the mom. He would pause and then walk away. There was no explanation for it."

"Everyone in the family could hear someone, something, walking upstairs when no one was on the second floor," James said. "There were always noises, people walking, and that man in the old-fashioned suit. He, that man, was just too much to deal with. They moved out because of him."

The most talked-about hauntings are at the Cordage Commerce Center, formerly the Plymouth Cordage Company. The entire compound of multiple buildings, parking lots, train tracks, tunnels, smokestacks, oceanfront and the abandoned Walmart is commonly referred to by locals as Cordage Park, or simply the Cordage.

Listed here are the most frequently reported haunted happenings:

Strange, eerie music heard late at night
An elevator operating on its own
Sounds of children playing in the hallways
Dragging noises of chains and heavy ropes
Cries of anguish heard from the smokestacks
Cries and shrieks of a small boy who was killed in one of the smokestacks when he was sent in there to clean it; he also throws rocks at people
Footsteps reportedly heard all around the property in all existing buildings and where structures no longer exist
Evil laughter
A woman dressed in eighteenth-century clothing roaming the halls

In addition, after the Cordage site became mixed-use office space, calculators and printers would operate on their own and phones would go out of order with no obvious explanation.

Many of the stories—urban myths, really—appear on the Internet or are passed down and around Plymouth. The common theme to these stories are teenagers or twentysomethings sneaking onto the property or into the vacant buildings and equipment areas at night. Some of the stories involve satanic rituals performed in the abandoned underground train tunnels. True or false? Fact or fiction?

The Cordage was patrolled by security during the time that it was vacant and when it was in transition from a manufacturing center to a

shopping mall and then to its current mixed-use incarnation. Safety was a major concern of the owners. Over time, most of the vacant buildings have been repurposed or torn down. The Cordage has become a vibrant center of business and a vital resource for the citizens of Plymouth and surrounding towns.

I visited with William Rudolph, president of the Plymouth Cordage Museum. When asked his opinion of the multitude of reported hauntings, Bill replied with a chuckle, "Laughter and music late at night? That's coming from the Black Raspberry Pub." The pub is a popular watering hole on the southeast side of the property.

Since 1980, Bill has been associated with the Cordage Commerce Center, having served as the property/construction manager and general manager and now as the president of the Plymouth Cordage Historical Society. He is a source of knowledge of the Cordage's history.

Bill is also no stranger to ghosts and has had his own face-to-face encounter with one at a home in Halifax, Massachusetts, in the 1980s. He and his wife were attending a party at the Sturtevant House. In the 1870s, that house was the site of a horrifying triple murder. Two brothers, Simeon and Thomas Sturtevant, and their maid, Mary Buckley, were viciously attacked by the Sturtevants' nephew, William. The weapon was a stake, and the motive was robbery. William was later hanged at Plymouth's 1849 courthouse in Town Square.

Bill describes a lovely evening of conversation. As the night was drawing to a close and guests were saying goodbye, Bill and his wife, Grace, remained behind with the hosts for a few minutes. They learned that the date just happened to be the anniversary of the triple murder.

What happened next was more interesting. The hosts described odd happenings in the house. For example, a door that was nailed shut opened on its own, and footsteps, noises and other run-of-the-mill events would occur without explanation. They swapped stories about the history of Halifax and continued to enjoy their evening when, all of a sudden, a one-dimensional black shape slowly moved against a wall from right to left.

Bill said, "It looked like a bear. All four of us saw it."

With that, the night was over.

"What about the Plymouth Cordage Company? Any ghosts there?" I asked.

"I know every inch of this property, and I've been here at all hours and times, and I have never witnessed anything," replied Bill.

There have been a few people killed here when it was the rope factory. There is an industrial railroad tunnel with underground tracks. There were once eight locomotives that powered forty flatcars over five miles of tracks here at Cordage. Raw materials were transported from the docks to the mills, and the finished product was transported to the warehouses.

Here at Cordage, they had a double track system. When the trains were set to enter the tunnel, one of the men would have to go down into it first to make sure it was clear.

Allegedly, the engineer was drunk at the time, I don't know, but this particular time one of the men sent to check for a train was hit by another train and killed in the tunnel.

Patrice Hatcher—psychic, photographer and interior designer—shared her impressions of the Cordage. "I used to have a shop there. The main factory site, I don't get very much from that, maybe some emotion and oppression. A lot of people worked there for more than a hundred years, so I expect that kind of feeling." She added, "As far as elevators moving on their own, and kids in the chimneys, I don't see anything like that."

Railroad tracks on the water side of the former Plymouth Cordage Company warehouses, facing north. This is now part of Cordage Commerce Center. *Patrice Hatcher Photography.*

"But it is the train tracks, that's where I feel something." Patrice said, "Looking north, I have a vision when looking at those railroad tracks and the warehouse to the left. It's a vision of someone run over by and stuck underneath a train."

Today, those tracks transport commuters to and from Boston on the Massachusetts Bay Transportation Authority's (MBTA) Kingston/Plymouth rail line.

Two former properties of the Cordage Park compound, one still standing and one demolished, have sinister and sad histories. The building of Harris Hall was funded in 1902 by the Cordage Company's largest stockholder, Edward R. Harris, as a company restaurant to feed the growing number of workers. It was enlarged twice over the years and, in 1949, "served an average of 225 dinners in a day in addition to about 525 sales of light refreshments."[67] Harris Hall was demolished in the latter part of the twentieth century.

Adjacent to Harris Hall is an office building that has had a long and varied history serving both the Cordage and the greater Plymouth communities. It was built as the Cordage Company's auditorium and recreation center. Over the years, it became a teen "drop-in" center, a war museum and then an office building. For a short time, a division of the state's unemployment office was located there.

In 1992, Harris Hall was an abandoned warehouse building called 385R. It was connected by an enclosed walkway to the office building on Court Street. It was also the scene of a horrible crime.

Twice-convicted rapist Michael Kelley spent thirteen years in prison before being declared "not sexually dangerous" and released into the general public in 1991. Just months later, he was a murderer.[68]

According to court documents, "Kelley obtained employment through a program sponsored by the DMH [Department of Mental Health] at a sign company situated next door to the residence of [one of the victims]….On April 13, 1992, approximately five months after Kelley had been paroled, he killed [the first victim]. In September, 1994, Kelley pleaded guilty to murder in the first degree."[69]

Kelley trolled for victims near where he was a sign painter on the northwest corner of Cordage property. His ruse was simple: offer women seeking employment at the state office the prospect of a job, trap them and kill them. He met his victims on the granite steps outside the unemployment office.

Kelley tried to lure at least eight women with the promise of a job while sitting on those granite steps. He succeeded in abducting and murdering two

Vintage postcard of Plymouth Cordage Company's Harris Hall, west-side view. It has since been razed. *The Hugh C. Leighton Company Manufacturers, Portland, Maine.*

of them. Tragically, the victims' remains were found in 385R, the former Harris Hall, and in his backyard in nearby Pembroke, Massachusetts. Following a nationwide search, Michael Kelley was apprehended in Florida and then extradited back to Massachusetts, where he went on trial and was convicted of murder and is now serving life in prison.

People who work at the office building that was once attached to the now-demolished Harris Hall claim that it is haunted. I interviewed a former tenant of the building, who wished to remain anonymous.

"I couldn't help but feel uneasy in my office after dark," she said. "We had a suite of rooms, and I later found out that it was at our office where the two buildings were once connected."

She continued, "After dark, it was particularly unnerving. For whatever reason, I always felt like someone was looking in the window that used to be the walkway entrance/exit of the building to Harris Hall. It was eerie and creepy, and the hair would stand up on the back of my neck when I had to pass by that area at night."

That was not her only experience.

"Of course, you always hear about electronic equipment going haywire in the area of a haunting. Well, I had a laser printer/scanner combination that would operate on its own during the day when nothing had been sent to

print. We called in our technical support person to check on the connections and to see if something was wrong with the printer. He couldn't find anything wrong with it, and it never 'malfunctioned' in his presence."

"Without prompting, the printer would just start printing blank pages, multiple pages, over and over. This happened a few times a week. It was very strange, and it didn't stop 'malfunctioning,' for lack of a better word, until after we moved offices," she said.

Could there be a likely explanation for a printer operating on its own? Perhaps, but with the amount of paranormal activity in North Plymouth, one cannot say for sure who or what the culprit is. An angry Native American Indian, a former factory worker, a tragic victim of crime—one or all could have left their spirit behind at the Cordage.

9

PLYMOUTH'S HAUNTED LIGHTHOUSE AND MYSTERIOUS COAST

No ghost-story book would be complete without a tale of a haunted lighthouse. This one also contains the story of the mysterious disappearance of two boys from Plymouth.

One of America's oldest wooden lighthouses, Plymouth's Gurnet Lighthouse has warned sailors of danger since Revolutionary times. The first light on the gurnet, rudimentary in design, was described as "lanterns raised on poles, as early records do not refer to any type of structure having been erected."[70] That was in 1710. Different structures served as the beacon throughout the centuries. The current lighthouse was built in 1843. It was once one of two towers watching over the entry to the north side of Plymouth Harbor from the sand dune at Duxbury. It has been reported that the lighthouse is haunted by the wife of a former keeper. Some have seen her at the windows, gazing out at the horizon, awaiting her husband's return.

Every lighthouse has a story. There is a romanticism about lighthouses. The ocean. A windswept, rocky coast. A storm. A beacon of hope. The only light in a cold, dark night. Rescues. Heroes. Mystery. Loneliness. The very mention of a lighthouse evokes the most quixotic of images in the mind's eye.

Lighthouse keepers, or "wickies," were very often thought of as solitary individuals. Wickies was the name given to light keepers because they were responsible for trimming the wicks of the candles of lights that shone over the coast and out to mariners before lighthouses were mechanized. Lighthouses, through their signals, kept mariners aware of an approaching rocky coast

or the threat of bad weather, was an aid in navigation and helped thwart the dangers that could trap a ship on an angry shoal. Lenses illuminated by oil lamps and, prior to that, wood fires, and wicks were the norm until Thomas Edison made electrification an effective and efficient means of operating these coastal beacons worldwide. It took about one hundred years for most lighthouses to be mechanized. Few lighthouses in the world remain "manned" or "womaned." The United States Coast Guard is the steward of most of the lighthouses dotting American shores, with some lighthouses, like Boston Light, manned by volunteer keepers.

Mariners see lighthouses as visual markers. They are vitally important to their survival. So, while people see lighthouses, what do the lighthouses see? Did the Plymouth's Gurnet Light see what happened to Robert Rasmussen and Gerald Montrio?

The year 1957 was an epic one for the town of Plymouth. On June 13, *Mayflower II* made its historic voyage to commemorate the Pilgrims' Atlantic voyage from England, and the town was in the international spotlight once again. *Mayflower II* was an authentic reproduction of the ship that transported the Saints and Sinners to the New World. In fact, *Mayflower II* took the same route that *Mayflower* captain Christopher Jones had in 1620. Then, the Pilgrims landed in a world different from any of their expectations when they embarked from Plymouth in England. The *Mayflower II*'s crew and passengers knew what awaited them in Plymouth: a celebration of monumental proportions.

But, just less than three months later, townspeople would be faced with the mysterious disappearance of two boys, ages thirteen and fifteen. The boys' clothing would later be found on Flat Rock, near where thousands had celebrated *Mayflower II* just a few months before. Did they drown? Did they run away? Were they abducted? Sixty years later, their families are still looking for them.

It was September 9, 1957, to be exact. According to the *Mohave Valley Daily News* of July 20, 2003:

> *The Old Colony Memorial, Plymouth, Mass., reported in June* [2003] *that witnesses also had seen two boys with bundles of clothes getting in and out of a boat, plus friends of the boys reportedly told police the missing duo had saved money and practiced hopping freight trains after running away to Boston once before. The newspaper also reported a firefighter, Lenny*

Sullivan, who had been part of the search party, believed the boys had drowned and the bodies fell prey to the "wildlife of the ocean." [71]

The story goes that Gerald Montrio and Robert Rasmussen were two ordinary teens, itching for adventure and fearful of parental consequences due to their activities of youthful exuberance. There was nothing unusual about them, nothing to draw any attention to them.

Gerald's and Robert's sisters have not forgotten about them and have continued to look for them for the past sixty years. After forty-six years had passed, the two sisters, Rasha Razbeau (formerly Rachel Montrio) and Joyce Rasmussen Balint, took their search west.

"Route 66 was the way to hitchhike west," Balint said. She said television was full of western movies and the boys heard the phrase "go west, young man," over and over. Balint said the Montrio family owned a lot of land and horses. Both the boys knew how to ride horses, hunt and fish.

Balint, who was 8 at the time her brother vanished, said police never spoke to the siblings. Her younger brother Wesley Rasmussen, 4 at the time, said he had asked to go to the beach with the older boys and was told by his big brother he could not go, because they were never coming back. Balint said the boy's account was dismissed because of his age. She said there are also witness reports that young men fitting the lost boys' descriptions were seen hitchhiking at about 4:30 p.m. They were last seen at home after school at about 3 p.m. Razbeau previously told the Sunday Express, Glasgow, Scotland, she remembered her brother being distraught about the eminent return of their father who was a Merchant Marine and away at sea. Razbeau said her father abused the boy.

She said days before Montrio's disappearance, he gave her a treasured signet ring, "in case anything happened to him." Balint said her brother feared their father's discipline would soon come to physical blows. The Rasmussens' father was also a member of the Merchant Marines. Balint said it could not have been a suicide pact. The boys were Boy Scouts, tall for their ages and knew how to take care of themselves. "Running away in the 50s would have been easy," Balint said. She said they could have passed as brothers too. Both had dark hair, dark eyes and olive skin. "My mom always stayed (in the home in Plymouth) in case Bobby came home," Balint said. [72]

Balint's mother passed away in 2005 at the age of eighty-two. [73] The boys have never been seen or heard from since that day in September 1957.

Anyone with information about the mysterious disappearance of Gerald Montrio and Robert Rasmussen are urged to contact the Plymouth, Massachusetts Police Department, 20 Long Pond Road, Plymouth, Telephone (508) 830-4218.

Plymouth's Gurnet Light and its sandbar at Brown's Bank are purported to be haunted. Sitting at the entrance to Plymouth Harbor, it is thirty-four feet tall, "overlooking where the Pilgrims' came ashore in 1620 and is one of America's earliest lighthouses being the eighth light built in the Colonies. The Pilgrims named the point 'the gurnett's nose' reportedly after the fish of that name which is caught off the coast of England."[74]

The book *Your Complete Guide to New England's Haunted Lighthouses* by Theodore Parker Burbank is a wonderful source to learn more about the history of Plymouth's Gurnet Light and all of the lighthouses in New England. Burbank provides excellent historical background relating to the land and surrounding coastline where the Gurnet Light stands.

> *The area surrounding the light known as Gurnet Point and Saquish Neck was occupied seasonally for thousands of years before Europeans arrived by the Womponoag Tribe. The Tribe lived throuout eastern Massachusetts and the Islands of Martha's Vineyard and Nantucket and would spend the summers here to avoide the heat and mesquitoes found inland. Saquish is a Womponoag word meaning "Place of many clams." In 1004 it is said, the ship of Eric the Red's son Thorwald was damaged off Cape Cod. Putting into shore for repairs to the keel. The ship was attacked by natives, and Thorwald was mortally wounded. After completing repairs, Thorwald and his crew sailed into a large bay and landed at the foot of a hilly, heavily wooded promotory (Gurnet Point). Tradition has it that Thorwald proclaimed at that spot, "It is beautiful here, I should like to affix my abode." Not long after this Thorwald died from the wounds he suffered in the skirmish with the Indians. His men buried him on Gurnet Point.*[75]

But what of the reported hauntings? When I asked psychic Patrice Hatcher her opinion of Gurnet Light, she said, "All lighthouses have stories of hauntings, either the actual building or the land. There is so much tragedy relating to lighthouses."

There are two ghost stories associated with the Gurnet Light. The first is that it is haunted by the widow of the first lighthouse keeper, John Thomas.

Plymouth's Gurnet Lighthouse in a present-day view from the harbor. *Patrice Hatcher Photography.*

It was on his land that the original lighthouse was built. Thomas was also a physician, and according to Burbank's book, he served in both the French and Indian War and the American Revolution. Thomas's wife, Hanna, was left on her own at the lighthouse while he was away. Thomas was injured at the Battle of Quebec and died from his wounds. Some believe that Hanna remains on watch at the lighthouse, waiting for her husband's ship to return.

> *In 1994, Bob and Sandra Shanklins of Fort Walton, Beach, Fla., who have photographed lighthouses all over the world, spent the night in the keeper's house near the tower. A little after midnight, Bob awakened to see the upper portion of a woman's body floating near the bed. He said the apparition had long, dark, shoulder-length hair and "very sad eyes." While there is no way to ascertain with any degree of certainty the identify of the Gurnet Point ghost, Shanklins claimed he had a "feeling" it was Hannah Thomas.*[76]

Burbank's book describes Bob's experience in even greater detail:

Something woke Bob. He rose up on his elbow and watched the light come around, illuminating the windows for a few seconds each time. Then he looked over toward me [Sandra] and saw the head and shoulders of a woman floating above my bed. He described her as having a green blue electric spark color. He said she had an old-time hairdo, sunken cheeks and the saddest face he ever saw. Bob told me that she wasn't wrinkled and he didn't think she was an old woman. He said he felt no threat from her, but only her sadness. As he watched her, out of the corner of his eye he could see the rays of light from the lighthouse come around several times, brightening the room. He looked toward the light, looked back to where she had been and she was gone.[77]

The second ghost story is about the ill-fated mariners of the brigantine *General Arnold*. It was here, during the Christmas Eve blizzard of 1778, that Captain James Magee's crew was stranded on the Brown's Bank sandbar just south of the gurnet. Captain Magee and his crew tried to get the *General Arnold* off the sandbar by chopping down the masts in an effort to make the ship lighter. It wouldn't budge.

The ship was on its way to the Carolinas from Boston, and snow had already started to fall when it left port. By the time the ship made it to Plymouth, it was clear that dropping anchor and riding out the storm was necessary. But the ship's anchor dragged, and just one mile off the coast of Plymouth, the *General Arnold* and its crew were trapped in an icy nightmare. For two days and nights, the ship was stuck. To make things worse, Plymouth's frozen harbor prevented help from arriving from the shore. The blizzard was harsh, and the temperatures were below zero.

"Pour the rum in your boots, not down your throats!" was the alleged command of Captain Magee when he and his crew of 103 were stranded on the white flats by the gurnet. Purportedly, there was rum and wine on the ship. By drinking the alcohol, frostbite and death would be inevitable, as the core body temperature would drop, making hypothermia likely. Pouring the spirits into their boots would prevent their feet from freezing, as alcohol freezes at a lower temperature than water. Magee ordered some of his crew to march in place until exhaustion almost killed them.

Plymouth residents could do nothing to help the sailors until December 28, when they built a walkway over the icy harbor. By then, it was too late for 70 of the 103 on board. Burbank describes the horrific scene: "Icy waves washed over her main deck and the captain later reported, 'The quarter deck was the only place that could afford the most distant prospect of safety.'

Magee went on to say 'Within a few hours, presented a scene that would shock the lest delicate humanity. Some of my people were stifled to death with the snow, others perished with the extremity of the cold, and a few were washed off the deck and drowned.'[78]

Dr. Thacher, Plymouth's physician and a subject of this book's chapter 4, was one of the first rescuers: "'It was a scene unutterably awful and distressing,' writes Plymouth's Doctor Thacher. 'The ship was sunk ten feet in the sand; the waves had been for about thirty six hours sweeping the main deck, and even here they were obliged to pile together dead bodies to make room for the living. Seventy dead bodies, frozen in to all imaginable postures, were strewn over the deck, or attached to shrouds and spars; about thirty exhibited signs of life, but were unconscious whether in life or death.'"[79]

On bitter cold nights, when the wind comes in off the harbor, many claim to hear the screams and suffering of the men left to freeze to death. One can only imagine the terror, pain, anguish, agony and fear they felt knowing they could not be saved.

In addition to Brown's Bank, the crew of the *General Arnold* are also said to haunt Plymouth's 1749 Courthouse and Museum located at Town Square.

Town Square's courthouse is a classic wood, white-washed New England structure located just a stone's throw from Burial Hill and backed up to the John Carver Inn. Among other uses than judicial, the 1749 Courthouse has served from time to time as a municipal building, a meeting place, a gallows and a morgue. It was here that the sailors were brought after freezing to death and here that they waited for relatives to claim them.

Dr. Thacher described the scene of the *General Arnold* and as townspeople shuttled the dead to shore and the makeshift morgue: "The bodies remained in the posture in which they had died, the features dreadfully distorted. Some were erect, some bending forward, some sitting with head resting on the knee, and some with both arms extended, clinging to spars or some part of the vessel. Sleds and slabs of wood were used to carry the survivors and the stiffened corpses over the ice road to shore. The dead were piled in the Plymoth Courthouse, the living brought to local homes to spend agonizing hours thawing out."[80]

Some say that a few of them remain behind, waiting to be claimed, tapping on the windows at passersby to get their attention. Apparitions of the dead are said to watch people at night.

When I asked Vicki Noel Harrington, owner of Spirit of Plymouth Walking Tours, if she had any tales involving the 1749 Courthouse and Museum, she replied, "I haven't seen or heard anything there, but the

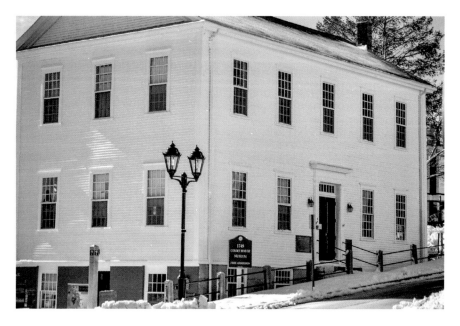

1749 Courthouse in Town Square in a present-day view. *Patrice Hatcher Photography*.

sailors' energy could remain. The building still has the same floorboards that they were laid out on. My experiences with the ghosts from the *General Arnold* all happened up by the Sailors' Memorial at Burial Hill." (See chapter 3.)

Combined with their painful deaths, the mariners are reported not to be resting at their place of death, the location where they were laid out for identification nor at their final place of rest. Haunting three places—Brown's Bank, the 1749 Courthouse and Burial Hill—must be an exhausting way for those tortured souls to spend their afterlife.

According to Burbank, a modern-day boater and his wife had an encounter with the ghosts when they were leaving Plymouth to return to their home port of Marshfield. It was a particularly foggy evening, and the pair had just avoided a near miss with the Plymouth-to-Provincetown ferry. The husband described the event to Burbank:

> *The boat passed and the fog began to lift so we were off Brown's Bank and heading home to Marshfield. My wife was very quiet the whole way back and after we were safely on shore I asked why she was so silent. Her reply—Brown's Bank is haunted! I had an overwhelming feeling of doom*

Memorial to those lost at sea, located on Plymouth's waterfront near Pilgrim Memorial State Park. *Patrice Hatcher Photography.*

and sadness that was so deep I felt I couldn't speak. I recognized the feeling as being exactly what I experienced when we were at Gettysburg where so many died in battle. The spirits of those poor souls lost in such awful conditions linger still and so do the frozen men from the "Arnold." [81]

Plymouth's Gurnet Light has witnessed a lot—mystery, death and despair, rescues and, now, the ghosts of its keeper and the crew of the *General Arnold*. The beacon shines on through it all.

Reader, take note: The Plymouth Gurnet Lighthouse is not open to the public. The gurnet itself is accessible only through Duxbury Beach by four-wheel-drive vehicle.

NOTES

Chapter 1

1. Ainsworth Psalter, Psalm 100.
2. Philbrick, *Mayflower*, 77.
3. Ibid., 67.
4. Ibid., 69.
5. Ibid., 79–80.
6. Browne, "Cole's Hill Sarcophagus and Pilgrim Remains."
7. Goodwin, "Page 158 [footnote]," *Pilgrim Republic*.
8. Philbrick, *Mayflower*, 99.
9. Lepore, *Name of War*.
10. Philbrick, *Mayflower*, 151–52.
11. Lodi, *Ghosts from King Philip's War*, 51.
12. Philbrick, *Mayflower*, 337.
13. Ibid., 337.
14. Ibid., 338.

Chapter 2

15. Oxford Living Dictionaries, "Plymothian."
16. Old Colony Club, "Founding of the Club."
17. Hymnary.org, "Breaking Waves Dashed High."
18. Plymouth Antiquarian Society, "Historic Sites."
19. Ibid.
20. Ibid.

Chapter 3

21. MacQuarrie, "Remains of Pilgrim Settlement Unearthed."
22. Ibid.
23. Ibid.
24. Ibid.
25. Perkins, *Handbook of Old Burial Hill.*
26. Burbank, *Guide to Plymouth's Historic Old Burial Hill*, 49.
27. Ibid., 121.
28. Geni.com, "Thomas Spear," "Elizabeth Russell Raymond," "Ida Elizabeth Spear," "Ida Lizzie Spear," "Thomas Irving Spear," "George Spear."

Chapter 4

29. Wikipedia.com, "Charles Bulfinch."
30. Chaffee et al., *Beyond Plymouth Rock*, vol. 2.
31. Ibid.
32. Ibid.
33. Goldstein, "Street from Yesteryear."
34. Ibid.
35. Chaffee et al., *Beyond Plymouth Rock.*
36. Ibid.
37. Rueherwein, "Our Night in a Haunted Hotel."

Chapter 5

38. Browne, "Haunting of the Capt. Phillips House."
39. Winiarski, "'Pale Blewish Lights,'" 497–98.
40. Browne, "Haunting of the Capt. Phillips House."
41. Winiarski, "'Pale Blewish Lights,'" 498.
42. Browne, "Haunting of the Capt. Phillips House."
43. Winiarski, "'Pale Blewish Lights,'" 500.
44. Browne, "Haunting of the Capt. Phillips House."
45. Law Office of Harold F. Moody Jr. P.C., "Winslow-Warren House."
46. James Baker, *A Guide to Historic Plymouth* (Charleston, SC: The History Press, 2008), in "Leyden Street," Wikipedia.
47. Harbert, "Husband Wanted for Murder," A1.
48. Harbert, "Murder Victim Was 'An Elegant Lady,'" A13.
49. Priston, "Suspect Caught at Casino."
50. Harbert, "Husband Wanted for Murder."
51. Priston, "Suspect Caught at Casino."
52. Harbert, "Husband Wanted for Murder."

53. Supreme Judicial Court of Massachusetts, Plymouth, *Commonwealth v. Victor A. Cardarelli, Third.*
54. Harbert, "Husband Wanted for Murder."
55. Ibid.

Chapter 6

56. Priscilla Beach Theatre, "Our History."
57. Wright, "Story Behind the Ritual that Still Haunts Broadway."
58. Town of Plymouth, "Full Text Annual Report Town of Plymouth."

Chapter 7

59. Wikipedia.com, "Concealed Shoes."
60. Ibid.

Chapter 8

61. Chaffee et al., *Beyond Plymouth Rock.*
62. Morison, *Ropemakers of Plymouth*, 94–97.
63. Ibid., 69.
64. Rudolph, "Plymouth Cordage Company Chronology."
65. Massachusetts Department of Conservation and Recreation, Division of Planning and Engineering, Resource Management Planning Program, September 2006. "Resource Management Plan: National Monument to the Forefathers, Plymouth, Massachusetts," 1.
66. Wikipedia, "National Monument to the Forefathers."
67. Morison, *Ropemakers of Plymouth*, 95.
68. Associated Press, "Paroled Rapist Enters Plea of Innocent to Two Murders."
69. Commonwealth of Massachusetts, Trial Court Libraries, *Paul Coughlin, administrator, & others vs. Department of Correction & others.*

Chapter 9

70. Burbank, *Your Complete Guide to New England's Haunted Lighthouses*, 118.
71. Jenney, "Forty-Six Years After Disappearance."
72. Ibid.
73. Cartmell Funeral Home, "Charlotte (Goldmeer) Rasmussen" (obituary).

74. Burbank, *Your Complete Guide to New England's Haunted Lighthouses*, 111.

75. Ibid., 117.

76. Holloway, "Ghosts of Massachusetts Lights."

77. Burbank, *Your Complete Guide to New England's Haunted Lighthouses*, 111–12.

78. Ibid., 113.

79. Ibid., 114–15.

80. Ibid., 115.

81. Ibid., 117.

BIBLIOGRAPHY

Ainsworth Psalter. Psalm 100, published 1612, brought to the English New World in 1620. https://www.youtube.com/watch?v=Xr__qFLb3gs.

Associated Press. "Paroled Rapist Enters Plea of Innocent to Two Murders." *Journal Times,* June 16, 1992. http://journaltimes.com/news/national/paroled-rapist-enters-plea-of-innocent-to-two-murders/article_3d4d13b2-4f46-5bf3-aac7-45ab55ade7c3.html.

Belanger, Jeff. *Weird Massachusetts.* New York: Sterling Publishing, Inc., 2008.

Browne, Patrick. "Cole's Hill Sarcophagus and Pilgrim Remains." *Historical Digression* (blog), September 30, 2013. https://historical digression.com/tag/coles-hill.

———."The Haunting of the Capt. Phillips House in Plymouth." *Historical Digression* (blog), October 5, 2014. https://historicaldigression.com/author/historicist/page/39.

Burbank, Theodore P. *A Guide to Plymouth's Historic Old Burial Hill, Stories from Behind the Grave Stones.* Millis, MA: Salty Pilgrim Press, 2006.

———. *Your Complete Guide to New England's Haunted Lighthouses.* Millis, MA: Salty Pilgrim Press, 2015.

Cacchione, Victoria. "Cole's Hill Week Three in Review." *Fiske Center Blog,* June 23, 2016. http://blogs.umb.edu/fiskecenter.

Cartmell Funeral Home. "Charlotte (Goldmeer) Rasmussen" (obituary), June 29, 2005. www.cartmellfuneralhome.com.

Chaffee, John, et. al. *Beyond Plymouth Rock.* Vol. 2, *A Welcoming Place.* Plymouth, MA: Plymouth Public Library Corporation, 2010. https://archive.org/stream/beyondplymouthro02chaf/beyondplymouthro02chaf_djvu.txt.

Chan, Yvonne. "Unsolved Mysteries in Mass." Boston.com, March 7, 2014.

Clark, Emily. "A Tribute to Michael 'Wolf' Pasakarnis." *Old Colony Memorial,* November 21, 2010.

———. "WOLF: Evidential Medium and Author Hosts Talk on 'Wolf's Message.'" *Old Colony Memorial,* July 21, 2015.

Commonwealth of Massachusetts . *Trial Court Libraries, Paul Coughlin, administrator, & others vs. Department of Correction & others*. 43 Mass. App. Ct. 809, June 13, 1997–November 14, 1997, Suffolk County. http://masscases.com/cases/app/43/43massappct809.html.

Davis, William T. *Ancient Landmarks of Plymouth*. Boston: A. Williams and Company, 1883.

———. *Plymouth Memories of an Octogenarian*. Plymouth, MA: Memorial Press, 1906.

Filipov, David. "The Mystery of Where Plymouth Got Its Start." *Boston Globe*, June 21, 2014.

For the Lost—California Kids Program. "Missing Person: Gerald Montrio." www.forthelost.org.

Geni.com. "Thomas Spear," "Elizabeth Russell Raymond," "Ida Elizabeth Spear," "Ida Lizzie Spear," "Thomas Irving Spear," "George Spear." 2017. https://www.geni.com/people/Thomas-Spear/6000000000284265066.

Goldstein, Karin. "A Street from Yesteryear." *Plymouth Patch*, January 11, 2012. https://patch.com/massachusetts/plymouth/a-street-from-yesteryear.

Goodwin, John A. *The Pilgrim Republic*. 1879. Tercentenary (1920) edition.

Harbert, Rich. "Death and Deception." *Old Colony Memorial*, February 13, 1997.

———. "Husband Wanted for Murder." *Old Colony Memorial*, January 16, 1997.

———. "Murder Victim Was 'An Elegant Lady.'" *Old Colony Memorial*, January 16, 1997.

———. "No Dice for Alleged Killer." *Old Colony Memoria*, February 6, 1997.

Holloway, Lee. "Ghosts of Massachusetts Lights." Prairie Ghosts, 2002. http://www.prairieghosts.com.

Hymnary.org. "The Breaking Waves Dashed on High." Thomas B. Cunningham (composer), Mrs. Felicia D.B. Hemans (lyricist). New York: S. Brainard's Sons, 1879. http://www.hymnary.org/text/the_breaking_waves_dashed_high.

Jenney, Kay. "Forty-Six Years After Disappearance, Women Seek Long-Lost Brothers." *Mohave Valley Daily News*, July 20, 2003. http://www.mohavedailynews.com/news/local/forty-six-years-after-disappearance-women-seek-long-lost-brothers/article_c11393dc-b2ff-5072-91ad-668aad6c7771.html.

Klein, Christopher. "In Plymouth, Mass., Ghost Stories Satisfy the Halloween Appetite." *Boston Globe*, October 28, 2012.

Law Office of Harold F. Moody Jr., P.C. "The Winslow-Warren House." 2014. http://www.plymouth-attorney.com/the-winslow-warren-house.

Lepore, Jill. *The Name of War: King Philip's War and the Origins of American Identity*. New York: Alfred A. Knopf, 1998.

Lodi, Edward. *Ghosts from King Philip's War*. Middleborough, MA: Rock Village Publishing, 2006.

MacQuarrie, Brian. "Remains of Pilgrim Settlement Unearthed." *Boston Globe*, November 23, 2016.

Massachusetts Department of Conservation and Recreation. Division of Planning and Engineering. Resource Management Planning Program. September 2006. "Resource Management Plan: National Monument to the Forefathers, Plymouth, Massachusetts," 1.

Morison, Samuel Eliot. *The Ropemakers of Plymouth*. Boston: Houghton Mifflin Company, 1950.

Old Colony Club. "The Founding of the Club." 2004. http://oldcolonyclub.org/ClubHistory/occhist1.htm.

Oxford Living Dictionaries. "Plymothian." Oxford University Press, 2017. https://en.oxforddictionaries.com/definition/plymothian.

Perkins, Frank Herman. *Handbook of Old Burial Hill, Plymouth, Massachusetts*. Plymouth, MA: A.S. Burbank and Company, 1896.

Philbrick, Nathaniel. *Mayflower: A Story of Courage, Community, and War*. New York: Viking, Penguin Group, 2006.

Plymouth Antiquarian Society. "Historic Sites." http://www.plymouthantiquariansociety.org/historic.htm.

Priscilla Beach Theatre website. "Our History," 2017. http://www.pbtheatre.org/#.

Priston, Terry. "Suspect Caught at Casino." *New York Times*, February 6, 1997. http://www.nytimes.com/1997/02/06/nyregion/suspect-caught-at-a-casino.html.

Rudolph, William. "Plymouth Cordage Company Chronology." March 2006.

Rueherwein, Robin. "Our Night in a Haunted Hotel." *Massholemommy.com* (blog), September 17, 2013. http://massholemommy.com/2013/09/17/our-night-in-a-haunted-hotel.

Strangeusa.com. "Cortage [sic] Park." http://www.strangeusa.com/Viewlocation.aspx?id=5003.

Supreme Judicial Court of Massachusetts. *Plymouth. Commonwealth v. Victor A. Cardarelli, Third.* http://caselaw.findlaw.com/ma-supreme-judicial-court/1139247.html.

Town of Plymouth. "Full Text Annual Report Town of Plymouth,"1984. https://archive.org/details/annualreportoft1984unse_0.

United Press International. "Suspect Faces Second Murder Charge in Case of Missing Woman." *UPI Archives,* June 12, 1992.

Wikipedia.com. "Charles Bulfinch." https://en.wikipedia.org/wiki/Charles_Bulfinch.

———. "Concealed Shoes." https://en.wikipedia.org/wiki/Concealed_shoes.

———. "Leyden Street." https://en.wikipedia.org/wiki/Leyden_Street.

———. "National Monument to the Forefathers." https://en.wikipedia.org/wiki/National_Monument_to_the_Forefathers.

Winiarski, Douglas L. "'Pale Blewish Lights' and a Dead Man's Groan: Tales of the Supernatural from Eighteenth-Century Plymouth." *William and Mary Quarterly* (1998).

Wright, Andy. "The Story Behind the Ritual that Still Haunts Broadway." Atlas Obscura, October 1, 2015. http://www.atlasobscura.com/articles/the-story-behind-the-ritual-that-still-haunts-broadway.

ABOUT THE AUTHOR

As a child, Darcy H. Lee developed what became a lifelong curiosity about the paranormal and made it her hobby to collect ghost-story books on her travels throughout the world. A nonprofit executive by trade, Lee specializes in fundraising and development and has raised millions of dollars to benefit charities and the communites they serve. She has a BA in history from Marymount College at Fordham University and lives in southeastern Massachusetts. This is her second book.